Brushstrokes of Yesteryear

A Painting Journey for Folk and Decorative Artists

Christine Whipper and Deborah Kneen

MILNER CRAFT SERIES

First published in 2001 by
Sally Milner Publishing Pty Ltd
PO Box 2104
Bowral NSW 2576
AUSTRALIA

©Christine Whipper and Deborah Kneen, 2001

Design by Anna Warren, Warren Ventures Pty Ltd
Editing by Anne Savage
Illustrations by Deborah Kneen and Christine Whipper

Printed in Hong Kong

National Library of Australia Cataloguing-in-Publication data:

Whipper,Christine.
Brushstrokes of yesteryear: a painting journey.

ISBN 1 86351 290 X.

1.Decoration and ornament. I. Kneen, Deborah. II. Title.
(Series: Milner craft series).

745.723

Concept: Deborah Kneen and Christine Whipper

Disclaimer
Information and instructions given in this book are presented in good faith, but no warranty
is given nor results guaranteed, nor is freedom from any patent to be inferred. As we have no
control over physical conditions surrounding application of information contained in this
book, the authors and publisher disclaim any liability for untoward results.

Dedication

An angel's shout is but a whisper.

For my beloved father, 'Oscar'
C.W.

To my wonderful mum, Phyll
D.K.

Acknowledgments

We are indebted to our publishers, Libby Renney and Ian Webster
who have embraced this project with such enthusiasm
and professionalism.
Many thanks also to Anna Warren for her lovely design.

From Christine: A big thank you to my dear friend Deborah,
for your constant support and friendship.
To my beloved Ron, thank you for always being there for me.

From Deborah: A special thank you to Chris who is such an
inspiration both as a friend and as an artist. It has been a privilege to
work with her in the creation of our four books, not to mention the
teaching trips we have shared. And, as always, I am grateful to my
family for their love, encouragement and support.

Contents

General Tips and Techniques

*E*ach folk and decorative artist has his or her own way of approaching a painting and we encourage you to follow your own instincts and to experiment with your own ideas. The methods suggested in the instructions for each project are just one approach. There are many paths to a successful painting. The key is to paint from your heart and you cannot go wrong.

If you are a novice painter, you may feel the need to follow the instructions exactly—and this is fine. But as you gain more experience, use our instructions as guidelines only. We have tried to be comprehensive, but not prescriptive, to allow you the freedom to explore your own imagination.

Try adapting the patterns and varying the colours. Put your own personal stamp on the work. Once you inject your personality, you raise the painting process from the level of workmanship to the level of creative expression.

Similarly, we have not been prescriptive about brushes—everyone has his or her own favourites. You certainly don't need a lot of fancy brushes, particularly if you are a beginner. We tend to use round brushes—a No 1, 2 or 3 for smaller work and a No 4 or 5 for larger areas and then a liner brush for fine details. Christine sometimes uses a No 4 filbert in place of a round. She also prefers a dagger brush for her washes and blushes. In addition, Deborah likes to use flat brushes for floated colour and for some doubleloaded effects.

You will find lots of handy hints scattered through this book but here is a basic guide to the various methods we use.

What you will need

A basic checklist for the projects in this book would include:

- Jo Sonja's Artists' Quality Background Colours and tube Artists' Acrylics in the selection of your choice

- 1 in (25 mm) flat basecoating brush or sponge brush

- No 2 and No 4 round brushes

- Selection of flat brushes, say a ¼ in (6 mm) and ½ in (12 mm)

- Liner or mini liner brush

- ¼ in (6 mm) or ½ in (12 mm) dagger brush

- No 4 filbert brush is optional but worth putting on your wish list!

- Jo Sonja's Flow Medium for linework

- Sandpaper or sanding block and mask

- Chalk pencil

- Tracing paper

- White and grey transfer paper

- Stylus—an empty ballpoint pen will do

- Eraser

- Water jar or brush basin

- Palette

- 1 in (25 mm) cheap, flat basecoating brush or 2 in (50 mm) sponge brush

- Soft, lint-free cloth or paper tissue for wiping brushes

Transferring a pattern

Trace the pattern onto tracing paper. Place the tracing on the dry, basecoated wood surface and secure it with Scotch Magic Tape or masking tape. Slip a sheet of transfer paper underneath, ensuring the transfer side is downwards. Use either white or grey transfer paper—whichever will show up on your background. Transfer the basic outlines using a stylus. Dark pattern lines will be difficult to cover—so transfer lightly. Leave the pattern secured and slip it over to the back of the work. Then, if you want to transfer any details later, your tracing is still in place.

Basecoating

Apply your basecoat with a large flat brush (which doesn't shed hairs) or a foam or sponge brush—Christine's preferred method. Remember to allow each coat to dry before you apply the next. If necessary, sand lightly and wipe clean. Now is the time to add any special background effects such as sponging, dragging or scumbling/slip-slapping.

If you have mixed your own special base colour, always keep some extra in a plastic film container or small jar for touch-ups at the end. It's almost impossible to mix the same colour again. We know from bitter experience! This is particularly important if you are working on a solid background colour without special effects.

Creating a scumbled/slip-slap background

When we were preparing this book, we discovered we both love this background effect but Christine calls it 'slip-slap' while Deborah uses the term 'scumbling'! Christine works on the wet second basecoat while Deborah allows the base to dry and re-wets it with water or retarder. Either way, it produces interesting results.

Here is a detailed description of exactly what Christine does. Using a ¾ to 1 in (18–25 mm) flat brush, paint on the first basecoat (a medium to dark value colour) and allow to dry. Sand this first coat and wipe clean. Then paint with the base colour again. While the base is still wet, use the same brush, still with the base colour in it, and pick up the slip-slap colour, usually a light colour, for instance, Warm White.

Work this light colour into the base colour, wet-in-wet with a slip-slap

motion. Don't be tidy! If you have painted too much of the light colour, pick up extra base colour, blend into the brush and slip-slap this over the light colour to soften it. Allow to dry and then sand lightly. Christine suggests that you could experiment with up to four colours.

> *Painting tip:* When using several colours for a slip-slap background, choose colours in the same family. White will work with all colours.

Slip-slap backgrounds can be used to create the effect of a light source. If, for example, you place the light source at the top right, the darkest area is at bottom left. The transition from light to dark is gradual. Imagine there is a diagonal line running from the top left corner to the bottom right corner. Keep that imaginary line in your head as you work. In simple terms, the area around the line will be medium value, above it will be increasingly light and below it increasingly dark. Your lightest area will be up in that top right corner. Scumbled/slip-slap backgrounds are used in British Bouquet and It's a Dog's Life (see pages 48 and 89).

Blocking in

'Blocking in' is basepainting the shape with a smooth coverage of paint. Sometimes you will require an opaque coverage, which will mean several coats of paint. Let each coat dry before applying the next or the paint will lift.

Always block in following the direction of the petal or leaf. This is the tedious part of the painting process but once it's over the fun starts, with shading, highlighting and linework.

Christine's method of progressive highlighting— eliminating shading

Christine uses the base colour of the flower, leaf, ribbon or whatever as her shading colour and applies highlights over the top in layers. Many decorative artists basepaint their flowers in a medium value colour, then shade with a darker version of that colour and highlight with a light value. Christine's method is different, yet deceptively easy, because she starts with the darkest value. In most cases, this eliminates the need to shade because the base colour or background provides the shading.

The first point is to use creamy paint. Add just a little water so that the paint is the consistency of runny cream. The colour you use to block in the flower or other element will be the darkest value of that colour. It may not necessarily be a dark colour as such—just the darkest value for that element. You might commence a white rose with Unbleached Titanium—certainly not a dark colour in its own right.

Starting with the darkest colour means you don't necessarily have to shade. The shading colour is already there. All you need to do is to apply creamy layers of progressively lighter colour to the areas that reflect light and leave gaps for shadows. We call this progressive highlighting.

Leave shadows of the previous colour. These will be the separations between petals, at the base of a petal or leaf, in any indented areas such as beside a midrib on a leaf, where two edges overlap, under curled edges of petals and leaves and so on. So, when you apply each new layer, you will not completely cover the one before. It couldn't be easier!

You can also make the background colour work for you! If you paint a flower on a dark background such as Burnt Umber, block-in the flower and leave the background colour showing in the separations between the petals to form the shadows. Sometimes, however, this can look rather obvious—in that case, soften the shadows by painting a watery mix of the blocking-in colour over the top of the separations.

Don't try to build up the highlights too quickly. Your aim is soft, realistic highlights. If there is too great a difference in value between highlights, the effect will be harsh and unsubtle.

Painting tip: Add only a little Smoked Pearl, Unbleached Titanium, Warm White or other lightening colour each time you lighten the mix. And always use a dirty brush with the previous mix in it (see below).

Think about where the highlights will be placed—on front petals, convex surfaces, curled edges (sometimes called folds or 'turnbacks') and so on. The lightest value highlights will be where the light hits first, the places closest to the light source.

Let each layer of highlights dry before you apply the next or work wet-in-wet by adding Stroke and Blending Medium to the paint.

> *Painting tip:* Each layer of colour is a highlight, and each highlight will be lighter and smaller than the one before.

What is a dirty brush?

A dirty brush is the key to progressive highlighting. The term simply means that the brush still has some of the preceding colour in it. So don't wash out your brush between layers of highlights. With a dirty brush containing the previous colour, tip into Smoked Pearl or Warm White or the light colour of your choice. Mix the two colours together by brush-blending on your palette. That's all there is to it! Each time you do this, the resulting colour will be lighter. This is how Christine produces her graded colour values.

Graded colour values

In the instructions, the blocking-in colour is the first colour value, then that colour plus a lightener such as Warm White forms the next colour value, the resulting colour plus more lightener is the next colour value and so on. Usually Christine uses three colour values, supplemented by final Warm White highlights.

To summarise:

First colour value	=	Blocking-in colour
Second colour value	=	First highlight layer
Third colour value	=	Second highlight layer

Then a concentrated highlight is placed in the areas catching most light. Finally, tints (medium value transparent colours) are applied in the form of watery blushes of colour to create touches of sunlight (see below).

Using stroke and blending medium for wet-on-wet blending

Sometimes when Christine wants to achieve very subtle, diffused blending effects, she adds three or four drops of Jo Sonja's Stroke and Blending Medium to her highlighting colour mix and applies the highlights to a wet background. By adding the medium to the acrylic paint, wet-on-wet

blending becomes a very achievable technique. It's a good idea to add the medium, mix with the paint and allow the mixture to sit on your palette for about ten minutes until it reaches a spreadable soft butter consistency—like working with oil paints.

To highlight wet-in-wet, use a dirty brush of the previous mix and tip into Warm White. There is no need to blend the two colours together on your palette before applying to the surface, as you would normally do with progressive highlighting. You can blend on the painting itself.

Washes and blushes

Washes are watery applications of paint. The effect is transparent so that the underlying paint is still visible. Experiment with the consistency until it is right for you.

Painting tip: Wipe your brush gently on a cloth or tissue if the wash seems too runny or there is too much colour. It's always best to make a wash too light. You can always deepen a wash but the reverse is difficult. Use washes as the basis for a landscape. This technique is similar to that employed by watercolourists and in pen-and-wash designs.

You will see that Christine uses watery blushes of colour as a final step on many of her flowers and leaves. A blush is a watery application of transparent paint in a selected area—it is generally not as extensive in area as a wash. A blush is usually a medium value colour. However, Christine also uses 'ghostly' blushes (Warm White) and shadow blushes (Burnt Umber). More about these specialised light and dark value blushes later.

Blushes can enliven a flower or leaf—they add a touch of sunlight. Paint a blush of Yellow Light or Indian Yellow over an ordinary leaf and you will make it glow. Remember, just a hint of colour, in the same way as you might apply blusher to your cheeks. Too much and the effect becomes brash and obvious, particularly over highlight areas. You can be a little more daring when you paint a blush into shadow areas. Other good blush colours are any of the transparent reds, purples, browns and yellows on the colour chart. Sap Green is also a great blush colour and has been used on the rose leaves in Hidcote Bouquet (see page 39).

When you apply a blush, don't cover the entire leaf or petal. This will make it look all the same colour. Use blushes selectively.

> *Painting tip:* Always allow the underlying paint to dry before you paint a blush. If you don't, the paint may lift.

Christine uses a dagger brush for her blushes. You can't mistake a dagger brush—it looks like its namesake. Simply load with watery paint and then wipe the brush on your apron, an old cloth or whatever suits you! Wiping the brush is the key to keeping the wash subtle!

Blush highlights (Ghostly highlights)

Blush highlights of watery Warm White are sometimes applied as a finishing touch to petals, leaves and ribbons to make them shine. Christine calls these 'ghostly' highlights because they are white and transparent like a ghost! Ghostly highlights are added as the final touch when painting ribbon (Hidcote Bouquet, page 39) or porcelain (Through the Window, page 96). Use a dagger brush and remember to wipe it prior to blushing. This will ensure a soft effect.

Shadow blushes

Sometimes the method of working up from the shadows may not provide sufficient contrast. After you have completed the painting, consider whether any additional shadows are needed. It's important to remember that you can't have shadow without light so you must always have your highlights in place before applying any final shadows. Look at the Hidcote Bouquet project and see how final soft shadows of Burnt Umber have been applied with the dagger brush.

Flat brush techniques

DOUBLELOADING A FLAT BRUSH

Deborah likes to doubleload a flat brush to create her realistic rose leaves (see page 52). To doubleload is to carry two colours on the brush at the same time. Ensure that you have a generous pile of fresh paint and your paint consistency is creamy. Dress the brush in just a little Retarder or Stroke and Blending Medium and blot excess on a cloth or tissue. Load one corner with the lighter value colour and the other corner with the darker colour. Blend by stroking on a tile or firm palette to merge the two colours in the

centre of the brush. Choose a flat brush appropriate to the size of the element to be painted. For a leaf, the brush width should be approximately the width of one half of the leaf at its widest point.

SIDELOADING A FLAT BRUSH

Dress the brush in Retarder or Stroke and Blending Medium, blot excess and then corner into the colour of your choice. Blend on a firm surface until you have a soft gradation of colour from intense to soft to nothing on the unloaded corner. You may need to reload the brush if you were too sparing with the paint the first time.

Painting tip: Always blend on a firm surface such as a tile. Because pressure is needed, you cannot blend flat brush strokes successfully on a soft surface.

When you make your stroke, press down evenly and firmly on the bristles. Face the corner of the brush with the paint on it toward the area that is to be darkest (shading) or lightest (highlighting). If a harsh outline rather than a soft float results, it may be the caused by one of the following:

- You did not load enough paint.

- Your brush was too small—try a larger flat brush.

- You did not spend enough time blending before making the stroke.

- You were working up on the corner of the brush when you made the stroke rather than applying equal pressure across the bristles.

Here are some tips to help you:

- Load the brush in the base colour, then corner into the floating colour. This gives a softer effect but is only suitable for basepainted areas (not over staining, pickling, etc.).

- Pre-wet the area to be floated with just a little water or Retarder. The float will tend not to 'grab' the surface.

- Try to 'walk' the colour outwards as you apply the float to produce a wider shadow.

If the colour has spread right across the brush, wash it out and start again.

Different approaches to highlights

Consider the areas that reflect light. On a flower or leaf, any upturned, rolled or convex area will catch light. On a ribbon, the widest areas are usually the lightest. When painting highlights, there are several different approaches you can take.

- Christine's method of progressive highlighting (see page 10): over a dry base, paint on a highlight with paint of creamy consistency (but not too watery or it will run). For this method, use a colour only marginally lighter than the base. Too much contrast will not work. Build up layers of progressively lighter colour.

- Blend the highlight wet-in-wet by adding a touch of Stroke and Blending Medium to the paint. This is a very soft blending technique.

- Over a dry base, use a dry-brushing technique. Load a dry round brush with paint, wipe off excess on a paper towel so that little paint remains. Lightly brush on the highlight as if applying face powder.

- Try floating the highlight with a sideloaded flat brush. The underlying paint should be dry first.

- You can also apply a wash of watery white paint with a dagger brush (Christine's ghostly highlights), especially good on ribbons and leaves. Always wipe the dagger brush after loading.

Liner work

Use a No 1 round brush or a good quality liner brush. Christine favours No 1 and 2 mini liner brushes. The paint needs to be thinned to inky consistency for fine, sharp lines. Although we both believe water is perfectly adequate for thinning the paint, you will have more control if you use Jo Sonja's Flow Medium. Do note that if you add too much Flow Medium (or water for that matter) your lines will be too runny and they may blur. Experiment until you are familiar with the right inky consistency.

Painting tip: Roll your brush in the paint and Flow Medium mix so that the hairs are filled up to the ferrule and then roll off excess paint onto a soft cloth or tissue. This will help you to avoid making thick lines.

Wiping your round, filbert or dagger brush

It is important to wipe your brush to remove excess paint, particularly when using a very creamy or watery mix. We wipe our brushes without even thinking about it! Wipe after each brush load, before applying layers of highlights, painting washes and blushes, painting linework and so on. If you make a habit of wiping your brush, you will find it a great help. Christine uses her apron while Deborah uses a soft cloth or tissue.

Crackling

There are two different types of crackling, sandwich style and top crackling.

Sandwich style uses a product such as Jo Sonja's Décor Crackle. It produces large, rustic cracks. A basecoat is applied, then the Décor Crackle and finally a contrasting top coat which cracks, revealing the underlying colour. The Décor Crackle is the 'meat' in the 'sandwich', so to speak. This technique is not used in this book.

For these projects we have followed the top crackling method, using Jo Sonja's Crackle Medium. This is applied over a dry, finished painting. It creates tiny cracks resembling the crazing or craquelure on old oil paintings. When dry, it is usually antiqued to accentuate the cracks.

Make sure you have the correct crackle medium and do read the instructions on the bottle very carefully. Deborah has used Jo Sonja's Crackle Medium on the Staffordshire dogs in It's a Dog's Life, and you will find hints for its use there (page 93). One important piece of advice: it is always advisable to experiment first on a sample board if you have not used this product before.

Finishing techniques

ANTIQUING

We have left the painted bouquets for this book unantiqued so that the colours are clean and crisp. We have, however, used floated shadows and blushes to tone the colours. If you would prefer a more mellow look, you can antique your work, either the whole piece or selected areas. Before you start, erase any visible pattern lines and touch up smudges.

WATER-BASED ANTIQUING

Allow the painting to dry **completely**. Gently apply a thin pre-antiquing coat of Jo Sonja's Clear Glaze Medium to form a protective barrier and to allow longer working time. Do not overwork this coat. Let this coat dry thoroughly, preferably overnight. Mix Jo Sonja's Retarder and Antiquing Medium and the acrylic colour of your choice to inky consistency. Christine uses Burnt Umber while Deborah likes Brown Earth. You could also try Burnt Sienna or Paynes Grey. Apply the antiquing mixture with a soft cloth. Wipe off the excess with a clean cloth. Let dry and repeat for a deeper colour, if desired. We like to work just one flower or one area at a time, as the mixture does dry faster than oil-based antiquing. For floated antiquing, sideload a large flat brush with the mixture and float around the edges of your piece.

VARNISHING

Let the piece dry for at least a day before varnishing. Over water-based antiquing, apply Jo Sonja's Polyurethane Water Based Finishing Varnish in a satin or matt finish, using a ¾ to 1 in (18–25 mm) flat varnishing brush.

Whichever varnish you use, several thin coats are better than one thick coat. Let the varnish cure for a couple of weeks before using the piece.

General Tip: When attempting new techniques or varying those with which you are familiar, it is advisable to do a test sample first.

Always ensure that each stage of your painting is dry before starting the next. This will help to avoid problems such as paint lifting or bleeding.

Decorative Rose Sampler

From Deborah:

'The gardens of Great Britain and Ireland are filled with beautiful roses but there are other varieties that live only in the decorative arts. These are the rose motifs we find in places like museums, churches, castles and historic buildings, painted on wood, tinware, porcelain, walls, and ceilings, embroidered on fabric, woven into carpets, crafted in stained glass or carved in wood and stone.

'During my travels I soon filled a sketchbook with drawings of different decorative roses. Some are very stylised, reminiscent of heraldic emblems, while others are quite naturalistic. Following in the tradition of the roses map in Folk Art of France (Sally Milner Publishing), I thought it would be fun to take you on a creative journey to explore just a few of those rose motifs.'

General notes

What can you do with these roses? Why not use your favourite motif to decorate a brooch or the lid of a trinket box? Try one of the stylised roses such as the York, Lancaster or Tudor as a repeat element in a border on a box or tray. The naturalistic roses like the Pontypool or Wemyss look pretty painted in romantic swags or garlands.

'I've used a variety of painting techniques to interpret these roses. Some are undercoated in white to make the subsequent transparent red glow. Others are worked up from a dark base. Colour suggestions are provided for each rose, but do feel free to experiment.

'My favourite reds are Permanent Alizarine and Brown Madder, both transparent colours, and Red Earth, which is opaque. Lighten Permanent Alizarine with Unbleached Titanium. Try Naples Yellow Hue or Turners Yellow to create some lovely variations mixed with Brown Madder or Red Earth. I used a round brush for all the basic painting and strokework and a liner brush for fine work. A flat brush comes in handy for soft floated shadows. The grey-blue background of the colour plate is made with approximately two parts Warm White to one part French Blue.'

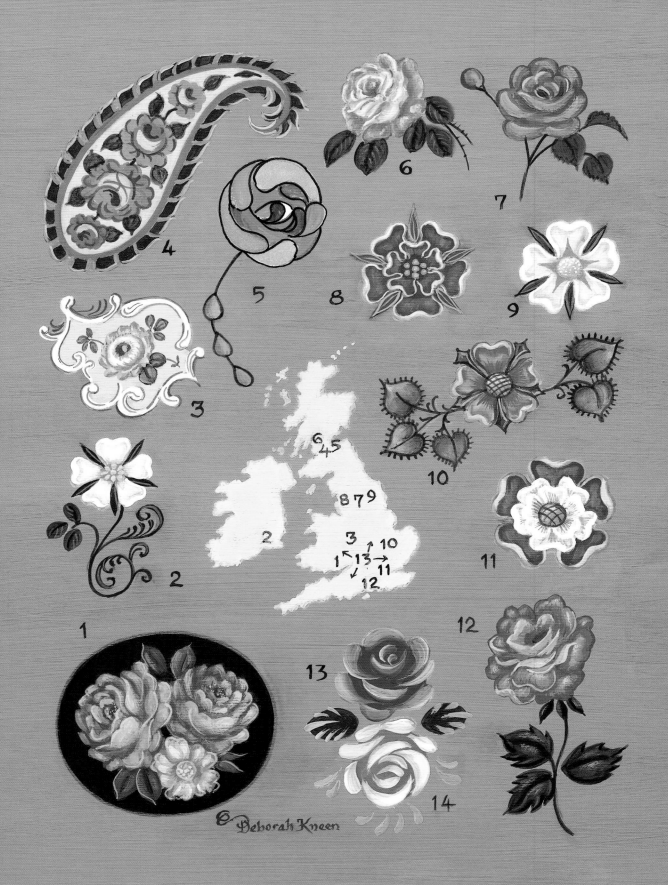

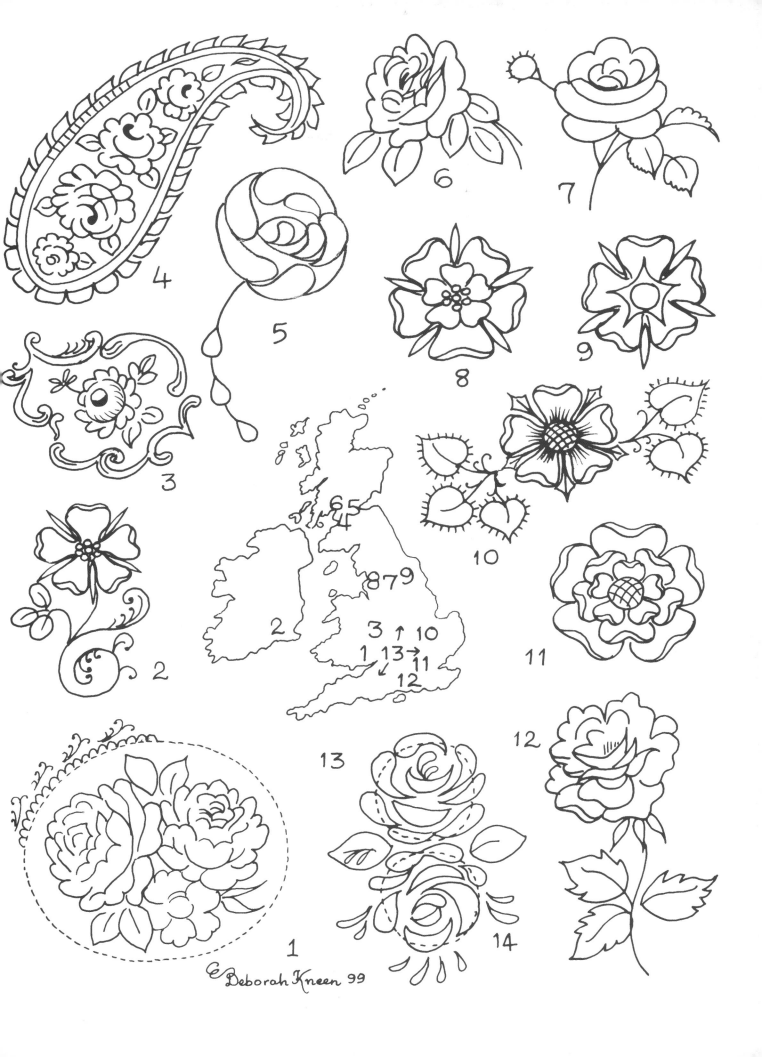

4

5

6

7

8

9

3

65

879

2

3 ↑ 10

1 13 → 11

12

10

11

2

13

12

1

14

Deborah Kneen 99

1. Pontypool rose

Soft roses inspired by French Rococo designs were often used to decorate the black japanned trays and other tinware produced in Pontypool and Usk in Wales during the eighteenth and nineteenth centuries and exported to North America. Pontypool trays are now highly prized collectables and fetch huge prices.

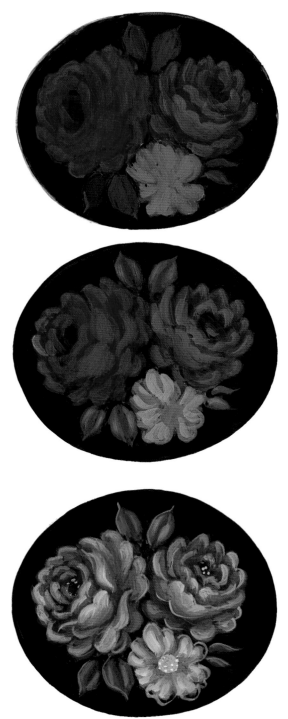

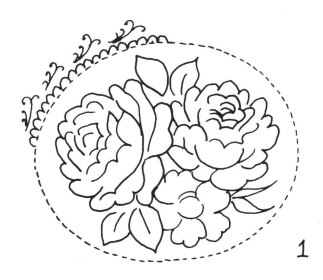

Paints

Brown Madder, Gold Oxide, Naples Yellow Hue, Olive Green, Permanent Alizarine, Turners Yellow, Unbleached Titanium, Warm White

INSTRUCTIONS

These roses look best on a black background, as in the traditional black trays. Apply your rose colour semi-transparently, using the black to create shadows and depth. If there is too much black showing at the end, paint over it with the base colour plus a little lightener.

Rose on left

Basecoat with Permanent Alizarine. It is a transparent colour so don't even try for opaque coverage. Leave the throat area black. Build up highlights of Permanent Alizarine plus Unbleached Titanium, making each layer lighter. Add a touch of Naples Yellow Hue to the highlight mix if desired. Don't lose the shadow areas. Finely outline some of the edges with the final highlight colour. Add Turners Yellow dots to the throat.

Rose on right

Basecoat with Brown Madder. Paint this rose in exactly the same way as the other but add Naples Yellow Hue to create the highlight colour.

Gold single rose at bottom

Basecoat with slightly watery Gold Oxide. Build up highlights on the centre of each petal with Gold Oxide plus Warm White. Add extra Warm White to each layer of highlights. Paint the centre of the rose in Turners Yellow. Add dots of Turners Yellow plus Warm White. Outline the petals with the lightest highlight colour.

Rose leaves

Base the leaves with Olive Green plus a tiny touch of Naples Yellow Hue for opacity. Lighten the area on either side of the central vein with a mix of

Olive Green plus more Naples Yellow Hue. Finely outline one side of each leaf with the same colour.

> *Painting tip:* If your highlights appear too bright or obvious, tone them by applying a 'magic wash' of the base colour over certain petals or even over the entire rose. Always ensure the underlying paint is dry before painting a wash.

2. Lismore rose

This stylised heraldic rose was painted on ceiling beams at Lismore Castle in Waterford in Ireland, probably in the mid-nineteenth century. It is in the style of roses used in wallpapers designed by Pugh who designed a lot of nineteenth century Irish interiors. This rose would be equally nice in red.

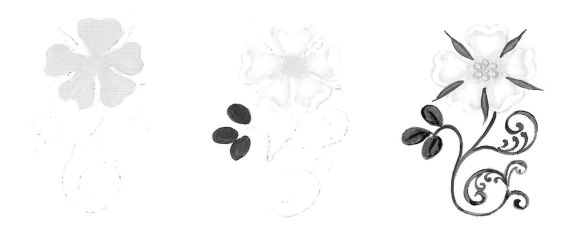

Paints

Carbon Black, Fawn, Naples Yellow Hue, Olive Green, Raw Sienna, Turners Yellow, Unbleached Titanium, Warm White

INSTRUCTIONS

This rose is best against a medium value or dark background. Basecoat with with a mix of Unbleached Titanium and a touch of Fawn. Depending on the colour of your background, two or three coats may be needed for good coverage. Follow the direction of each petal as you apply the paint. Let each coat dry. Paint a watery mix of Unbleached Titanium plus Warm White on the centre of each petal. Build up the curled edges with Warm White. If you

intend to antique later, build up the paint generously on these areas—it will look great when you antique. Leave shadows of cream base colour under the curled edges. The centre is composed of Turners Yellow dots. Highlight if desired with a tiny touch of Warm White.

Leaves

Paint the leaves and sepals with a mix of Olive Green and a touch of Naples Yellow Hue. When dry, add lighter colour side veins to the leaves and a central vein of Olive Green with a little Carbon Black. Paint the scrollwork lines with the leaf colour and shadow the outline here and there with the dark green mix.

3. Worcester-style rose

This is my interpretation of a typical Worcester porcelain rose with scroll cartouche, characteristic of the eighteenth century. Influenced by the porcelain of Sèvres and Limoges, the Worcester rose has strong colour contrast. It is compact with a plump bowl, dark, circular throat and neat skirt of petals.

 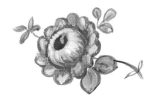

Paints

Brown Madder, Naples Yellow Hue, Olive Green, Permanent Alizarine, Turners Yellow, Warm White

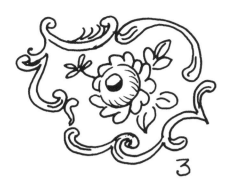

INSTRUCTIONS

Cartouche

Base the cartouche with a light yellow made with Turners Yellow and Warm White or try Naples Yellow Hue. You will need several coats for opaque coverage. The scroll is Warm White. Add Brown Madder linework.

Rose

Base the rose, section by section, with a mix of Brown Madder with a little Naples Yellow Hue to make a rich medium red. Highlight the petals and bowl with a lighter version of this colour—add extra Naples Yellow Hue and some Warm White. Remember to apply the highlights by following the shape of the element, for instance, curved strokes to suggest the spherical bowl of the rose. Finish with soft Warm White highlights. To shade the bowl, pull strokes of medium red up from the base of the sphere. Deepen the throat with Brown Madder as shown.

Leaves

Paint the leaves with Olive Green. Place highlights of Olive Green plus Naples Yellow Hue on either side of the central vein of each leaf. Outline the leaf with Olive Green if desired. Add fine Olive Green stems.

4. Paisley rose

Roses were sometimes used in floral designs on the paisley shawls made in nineteenth-century Scotland. The roses were contained within a paisley teardrop or tadpole shape. Overall designs were very complicated and intricate, influenced by Asian and Middle Eastern textiles.

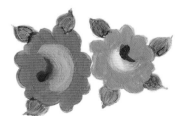
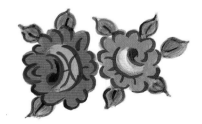

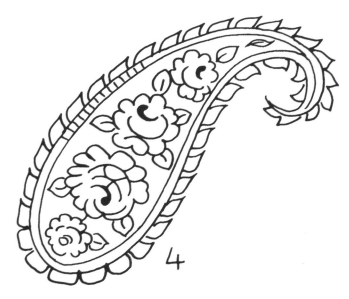

Paints

Brown Earth, Gold Oxide, Indian Red Oxide, Permanent Alizarine, Pine or Olive Green, Unbleached Titanium, Warm White

INSTRUCTIONS

Teardrop

Basepaint the teardrop with Unbleached Titanium. The 'fringe' pattern around the teardrop uses Pine or Olive Green and Gold Oxide, outlined with Unbleached Titanium.

Pink rose

Base with a medium lolly pink made with Permanent Alizarine and Warm White. Highlight the bowl area with a lighter version of the pink (add more Warm White). Outline with Permanent Alizarine. The throat is a 'tadpole' of Permanent Alizarine plus a little Brown Earth.

Gold rose

Base with a mix of Gold Oxide and Warm White. Highlight the bowl with a lighter version of the same colour. Add Gold Oxide linework and a 'tadpole' of Gold Oxide plus Brown Earth at the throat.

Leaves

Paint the leaves with watery Pine or Olive Green. When dry, outline with Pine or Olive Green.

5. Mackintosh-style rose

Scottish-born Charles Rennie Mackintosh (1868–1929) was a consummate architect, artist and designer who used the rose and rosebud motif in his stained glass, furniture, ironwork and other designs. The trademark Mackintosh rose is very stylised and modern-looking—instantly recognisable as his work. My rose is an adaptation, using teardrop shapes, the traditional building blocks of folk art. By colouring in the different sections with various pinks and reds, you can even create a stained glass look. The possibilities are many.

Mackintosh said: 'Art is the flower, life is the green leaf.'

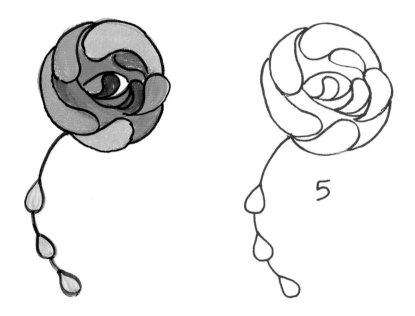

Paints

Reds and pinks of your choice, Warm White, Carbon Black

INSTRUCTIONS

Basecoat the rose and the teardrops on the stem with Warm or Titanium White. Apply the basecoat smoothly, following the shape of the petals. Allow to dry. When you apply washes of red over the top, the white will glow through. Try watery mixes of your favourite reds and pinks, painting each section in a different colour. If the washes are too streaky, allow them to dry and repeat, but don't make the colour opaque. When dry, outline carefully with Carbon Black.

6. Wemyss-style rose

Wemyss ware was produced at Wemyss near Glasgow from about 1880 to 1930 and is now highly collectable (the Queen Mother is an avid Wemyss collector). Pretty, plump red cabbage roses, often accompanied by thistles and shamrocks, decorate white porcelain items which include pigs and cats as well as the more usual plates, cups and other dinnerware. In the UK a Wemyss porcelain pig can fetch £1000 to £2500 at auction!

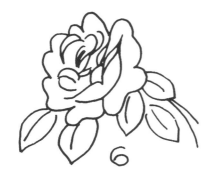

Paints

Brown Madder, Naples Yellow Hue, Olive Green, Pine Green, Warm White

INSTRUCTIONS

Rose

Base the rose in a medium coral red made with Brown Madder and Naples Yellow Hue. Allow to dry. Sideload a small flat brush and float Brown Madder in the throat, at the base of the petals and under the bowl. Build up highlights with a mix of the coral red and Warm White. Add final Warm White highlights on the bowl and the turned edges of the petals. Deepen the throat if necessary.

Leaves

Base with a mix of Olive Green and Pine Green. Highlight each side of the central vein by adding a touch of Naples Yellow Hue to the base colour. Add veins on either side of the central vein, using Naples Yellow Hue. Paint the stem and thorns with the base colour mix.

> *Painting tip:* If you want to avoid 'lolly' pink tones when mixing a pink colour from red, add a touch of a yellow such as Naples Yellow Hue rather than white to lighten the colour. This will produce a soft coral red.

7. Brontë rose

This simple folk art rose is inspired by the handpainted face of the Reverend Brontë's longcase clock at the parsonage in Haworth, Yorkshire. At 9pm each evening Mr Brontë would lock the front door, look in on his daughters in the dining room and remind them not to stay up too late. Then he would go up the stairs to the landing and wind his clock.

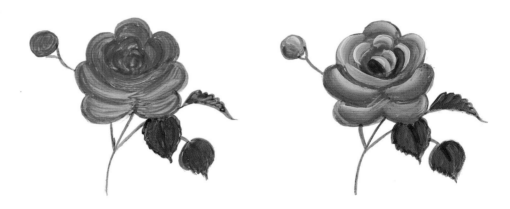

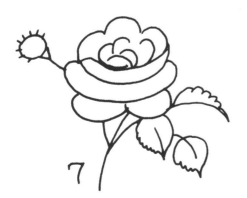

Paints

Brown Madder, Carbon Black, Naples Yellow Hue, Pine Green, Warm White

INSTRUCTIONS

Rose

Keep this rose simple and rustic. Base with Brown Madder, leaving the inner throat dark. Generously doubleload a largish round brush with Brown Madder and Naples Yellow Hue. Stroke the brush on your palette to blend the two colours just a little and then paint the

highlight strokes, reloading as necessary. Finally, deepen the throat with Brown Madder plus a touch of Brown Earth.

Leaves

Base the leaves with Pine Green. When dry, paint a wash of Pine Green plus Naples Yellow Hue on either side of the central vein. Outline the serrated edges of the leaves with Pine Green and a tiny touch of Carbon Black. Use this colour to paint the stem.

8. Lancaster rose

Legend has it that red *Rosa gallica* was brought back from the Holy Land by the Crusaders. Mediaeval illuminators liked its flattened circlet of petals and prominent sepals and used it often in manuscript borders. In a stylised form, it became the emblem of the House of Lancaster during the War of the Roses. From 1399 Lancastrians ruled England. In 1461 Henry VI was overthrown by Edward IV, a Yorkist. This is just one of many versions of the Lancaster rose.

 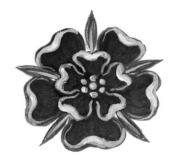

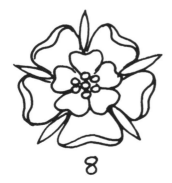

8

Paints

Brown Madder, Hookers Green, Naples Yellow Hue, Turners Yellow, Warm White

INSTRUCTIONS

Base the rose with Brown Madder. Highlight each petal with a creamy mix of Brown Madder and Naples Yellow Hue. Use this

colour on the rolled edges also, and highlight those edges with Warm White. Paint dots in the centre of Turners Yellow. Paint the sepals with a mix of Hookers Green and Naples Yellow Hue. When dry, add a vein of Naples Yellow Hue to the sepals.

9. York rose

The white *Rosa alba* became the heraldic emblem of the House of York. Yorkists ruled England under Edward IV and Edward V. There are also many variations of this rose.

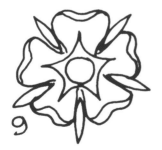

Paints

Carbon Black, Fawn, Naples Yellow Hue, Olive Green, Raw Sienna, Turners Yellow, Unbleached Titanium, Warm White, Yellow Oxide

INSTRUCTIONS

This rose is best against a medium value or dark background. Paint as for the Lismore rose (No 2). The 'star' at the centre is Yellow Oxide. Paint the central circle in Turners Yellow. When dry, add tiny dots of Warm White.

10. Chapel rose

This heraldic rose is adapted from the stained glass windows in Kings' College Chapel, Cambridge. Note the extremely stylised sepals and the charming heart-shaped leaves.

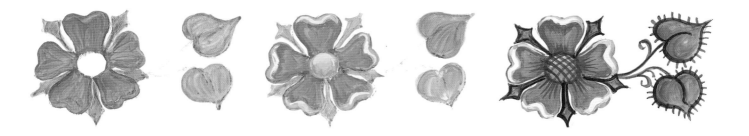

Paints

Brown Madder, Hooker Green, Naples Yellow Hue, Turners Yellow, Warm White

INSTRUCTIONS

Rose

To give the glow to this rose, underpaint it with Warm White. Allow to dry. Then base the petals with a creamy coral red made with Brown Madder and Naples Yellow Hue. Highlight the petals and their curled edges with a lighter version of this colour. Accentuate the curled edges by outlining them with Naples Yellow Hue. Paint fine Brown Madder lines radiating from the base of each petal. The centre is Turners Yellow. When dry, add cross-hatched lines of Brown Madder. Curve the lines to suggest the rounded shape.

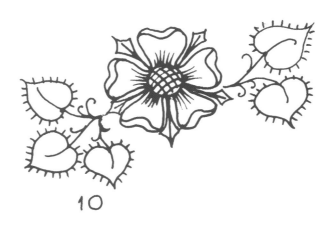

Leaves and sepals

Underpaint the leaves and sepals with Warm White and allow to dry. Paint the leaves with watery Hookers Green. While wet, deepen the green at the stem end of the leaf. Outline with Hookers Green and add the 'spikes' to the edges. Paint the sepals with Hookers Green. Outline one side of each sepal using a dirty brush (with Hookers Green still in it) and Naples Yellow Hue. Outline each sepal with Hookers Green.

11. Tudor rose

This is not a real rose but a heraldic motif. When the houses of York and Lancaster were united by the marriage of Henry VII (Henry Tudor) and Elizabeth of York in 1486, the white York rose was placed on top of the red Lancaster rose to produce this new variety that lives only in art and heraldry. The Tudor rose signified unity.

 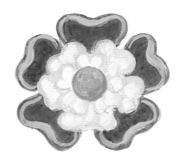 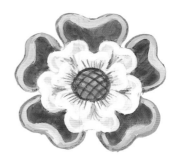

I have painted one basic version of the Tudor rose but there are a host of interpretations, including the central motif of the wonderful King Arthur's Round Table in the Great Hall at Winchester. The table is 18 feet (5.5 m) in diameter and bears a full-length portrait of King Arthur. It is divided like a dartboard into segments, designated with the names of Arthur's knights. Sadly, the table is not contemporary with Arthur himself who, legend has it, lived around 700AD. Carbon-dating suggests the table was made around 1400 in the time of Edward I, an admirer of the Arthurian legends. My theory is that the table was painted even later—hence the Tudor rose. No one really knows.

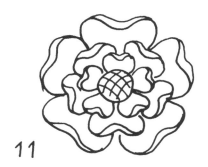

11

Paints

Brown Madder, Fawn, Hookers Green, Naples Yellow Hue, Raw Sienna, Turners Yellow, Unbleached Titanium, Warm White

INSTRUCTIONS

Paint the red petals as for the Lancaster rose (No 8) and the white petals as for the York and Lismore roses (Nos 9 and 2). When the white petals are dry, paint fine Brown Madder lines radiating from the centre. Paint the centre as for the Chapel rose (No 10).

12. Queen Victoria's rose

A carved and painted wooden rose forms part of the bow ornament of HM Yacht *Victoria and Albert* at the Royal Naval Museum, Portsmouth. In the carving the rose is teamed with the daffodil, thistle and shamrock.

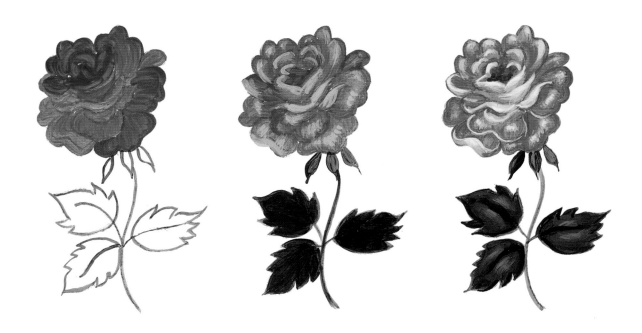

Paints

Brown Madder, Carbon Black, Naples Yellow Hue, Pine Green, Turners Yellow

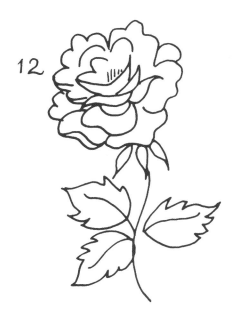

INSTRUCTIONS

Rose

Base the rose in a coral red made with Brown Madder and Naples Yellow Hue. Allow to dry. Sideload a small flat brush and float Brown Madder in the throat, at the base of the petals and under the bowl. Build up highlights slowly with progressively lighter layers of highlight mix—the coral red plus extra Naples Yellow Hue. Add a final highlight of Naples Yellow Hue to each petal. Use the same colour plus a little Warm White to highlight the turned edges. This will make them shine. Deepen the throat if necessary.

Leaves

Base the leaves with Pine Green. Highlight either side of the central vein with a mix of Pine Green plus Turners Yellow. Paint the central vein Pine Green plus Carbon Black and accentuate the serrated edges by painting a shadow-outline of the same colour.

13 & 14. Canalboat roses

Canalboat roses are usually painted in bright colours and teamed with pinwheel daisies and scenes of castles. They were used to decorate the narrowboats that plied Britain's extensive canal boat system in the nineteenth century. Prior to the advent of the railways, canals were the main method of transportation of goods. See also page 67.

Paints

Brown Madder, Pine Green, Turners Yellow, Unbleached Titanium, Warm White, Yellow Oxide

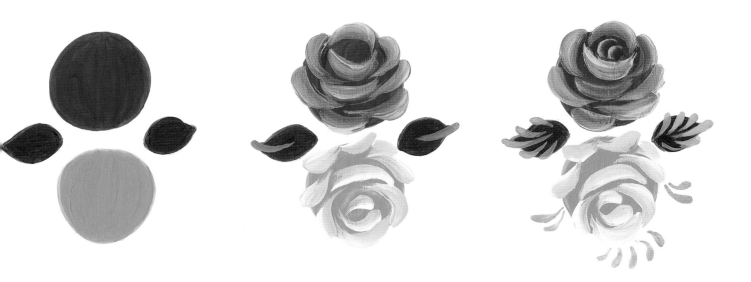

INSTRUCTIONS

Red rose

Base the circle with Brown Madder. When dry, doubleload your No 4 round brush with Brown Madder and Unbleached Titanium. Blend gently on your palette to merge the two colours just a little. Place the light colour towards the outer edge of each petal and paint the strokes. Reload and blend as necessary. Once dry, a second coat of strokework will give stronger coverage.

Yellow rose

Paint as for the red rose but base with Yellow Oxide and overstroke with doubleloaded Turners Yellow and Warm White.

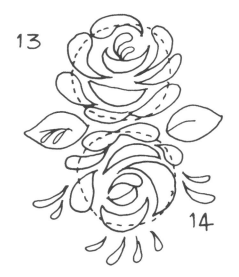

Leaves and commas

Base the leaves with Pine Green. When dry, use the dirty brush (with Pine Green still in it) to paint commas of Naples Yellow Hue.

Hidcote Bouquet

Christine describes her impressions of the famous Hidcote Manor Gardens in Gloucestershire, England: 'Flowers, pathways, water and trees. Sweet scents in the air. Colours are moving, scents are merging. Hues are delicate and rich, subtle and bold. Do we turn down this path or walk ahead? Roses, lilies, hollyhock, lavender and bees. Which one will capture my gaze first? No, I will have them all.'

Paints

Background colour: Purple Madder

Decorating colours: Burnt Sienna, French Blue, Indian Yellow, Pine Green, Purple Madder, Sap Green, Smoked Pearl, Ultra Blue Deep, Ultramarine, Warm White, Yellow Oxide

INSTRUCTIONS

Blue and white striped paper

Use your No 4 round brush and French Blue, Warm White, Smoked Pearl and Yellow Oxide. The blue stripe is French Blue while the white stripe is Smoked Pearl. When the French Blue stripes are dry, use a dirty brush of French Blue and pick up a small amount of Warm White. Mix the colours together on your palette and paint this paler shade of blue onto the highlighted areas. When the Smoked Pearl stripes are dry, highlight within the light areas using Warm White. For the fine yellow stripe between the blue and white, use a No 1 mini liner and creamy Yellow Oxide.

Highlighting the stripes

Load your ½ in (12 mm) dagger brush with watery Warm White and wipe off both sides of the brush. Pull this colour along the highlighted front. Repeat until you reach the desired effect.

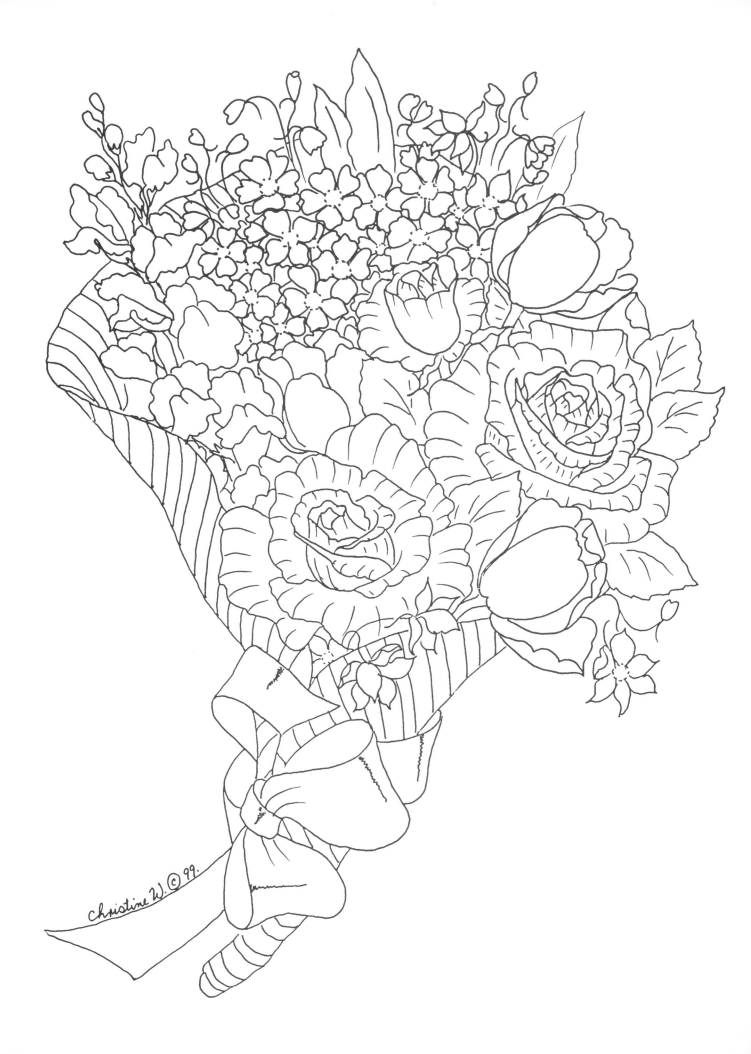
Christine W. © 99.

Pink bow and ribbon

First colour value: Block in the ribbon with the No 4 round brush and a mix of Smoked Pearl and Purple Madder (2:1). This produces the first colour value.

Second colour value: Using a dirty brush of the first colour value, pick up Warm White, mix the two colours together and pull this colour into the shape of the bow, leaving the blocked-in colour as shadow.

Third colour value: Using a dirty brush of the second colour value, pick up Warm White and highlight the front loops of the bow and ribbon.

Highlight: Paint Warm White as a narrow line down the front loops of the bow and on the ribbon to make them shine.

Ghostly highlight: Using your dagger brush and watery Warm White, paint this wash onto the front of the bow and ribbon.

Rose leaves

First colour value: Use Pine Green, Warm White and Burnt Sienna for the leaves. Block in the leaves with just one coat of Pine Green.

Second colour value: Using a dirty brush of Pine Green, pick up Warm White and mix the two colours together. Pull the paint from the edge and tip of the leaves down into the centre. Leave the Pine Green showing as separations and shadows. Work quickly, avoiding the shadow areas.

Third colour value: Using a dirty brush of the second colour value, pick up Warm White and paint this in the highlighted areas. Once again, don't spend too long on this—just lay the colour down quickly.

Highlight: Lightly paint creamy Warm White in the light areas.

Blush: Using your dagger brush and watery Sap Green, blush this colour out from the shadows, taking care not to cover all of the highlighted area. Remember that this is a blush, not a large wash.

Strappy leaves

Use the same technique as for the rose leaves, but pull the paint down to the bottom of the leaf, allowing the first colour value to show for the veins.

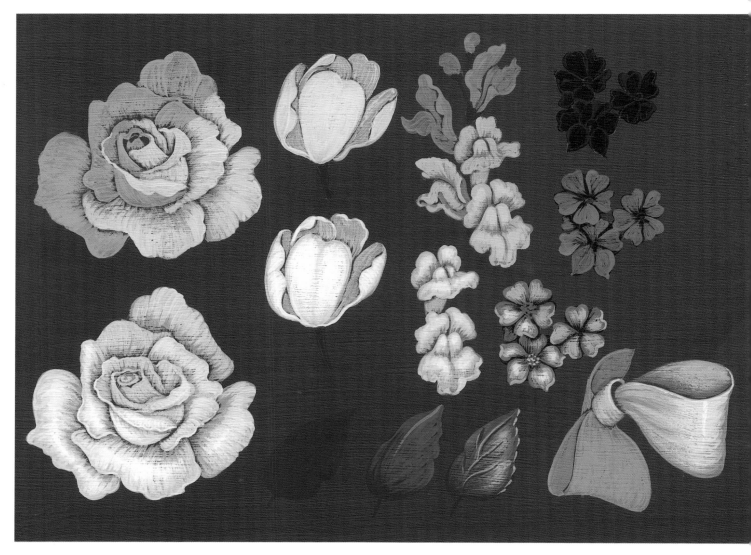

Outlining: Mix a pale green with Warm White and a small amount of Pine Green. With your No 1 mini liner outline one edge of the rose leaves and the strappy leaves.

Veins: Paint the veins softly with the outlining colour (pale green) and the No 1 mini liner. Follow the curve of the leaves. Shadow-outline the veins by using a slightly watery Pine Green and the mini liner. Remember to outline one side only of the veins.

Rust on the leaves: Paint the rust with watery Burnt Sienna and your dagger brush. Blush the colour onto a small area of the leaf. Don't paint rust areas on all the leaves—it would be boring. Use the rust here and there to create interest. After you have blushed this colour onto the leaves, touch more Burnt Sienna into the centre of the rust.

Delphiniums

Paint the delphiniums with your No 2 round brush and Ultra Blue Deep, Ultramarine, Smoked Pearl, Warm White and Pine Green.

First colour value: Block in all the petals and buds with a mix of Ultra Blue Deep and Ultramarine (4:1).

Second colour value: Using a dirty brush of the first colour value, pick up Smoked Pearl, mix the two colours together and paint the petals again, but this time leave touches of the first colour value showing for separations and shadow.

Third colour value: Using a dirty brush of the second colour value, pick up Smoked Pearl and mix the two colours. Paint this light colour onto the front flowers, leaving the second colour value down in the shadows and under petals.

Outlining: Add a touch of Smoked Pearl to the third colour value and outline the edges of those petals painted with the third colour value.

Highlight: Dab a highlight of creamy Warm White within the centre of those petals painted in the third colour value.

Centres: Mix a pale green (Warm White and a touch of Pine Green) and paint dots around the centre. Then pick up Warm White and paint a few dots over the pale green.

Shadow blush: Paint a shadow at the base of the delphiniums using watery Ultra Blue Deep and a dagger brush.

Snapdragon

Paint the snapdragon with the No 2 round brush and Yellow Oxide, Smoked Pearl, Warm White, Indian Yellow and Pine Green.

First colour value: Pull creamy Yellow Oxide down from the edge of the · petals, allowing touches of the background colour to show as separations. Paint only one coat. When dry, it will be a bruised colour. This will form the shadows and give depth to the flower.

Second colour value: Using a dirty brush of Yellow Oxide, pick up Smoked

Pearl, mix the two colours together and paint this onto the petals, leaving the first colour value down in the shadow areas.

Third colour value: Using a dirty brush of the second colour value, pick up Smoked Pearl and highlight the petals in the light area.

Blush: With your dagger brush and watery Warm White, blush here and there, particularly under the front petals on the base of the flower, behind the front petal and onto the two back petals.

Highlight: With a No 2 round brush and creamy Warm White, paint a highlight within the centre of the two back petals, onto the top of the front petals and onto the bottom front petals.

Outlining: Using the No 1 mini liner and Warm White, outline the edges of the highlighted petals with thick and thin lines.

Green stems

With the No 2 round brush paint the stems Pine Green. Then, with a dirty brush of Pine Green, pick up Warm White, mix the two colours together and touch this paler colour here and there onto the calyx and stem.

Tulips

For the tulips, use the No 4 round brush and Smoked Pearl, Warm White, Pine Green, Indian Yellow and Burnt Umber.

First colour value: Paint creamy Smoked Pearl onto the petals, pulling down from the top of each petal and allowing touches of the background colour to show here and there as separations.

Second colour value: Continue to use creamy Warm White but this time only paint the front petals and the tops of the folds (turnbacks or curled edges), leaving the 'bruised' colour on the inside of the back petals and at the bottom of the petals with folds.

Third colour value: Using a dirty brush of Smoked Pearl, pick up Warm White and pull this onto the curve of the front petals and onto the folds.

Blush: With your dagger brush and very watery Indian Yellow, paint a soft blush on the front petals.

Shadow: Using your dagger brush and very watery Burnt Umber, lightly paint a shadow behind the front petals, down the side of the front petals and under the folds.

Highlight: After you have blushed and shadowed, you can strengthen the Warm White on the folds and lightly outline the edges of the back petals.

Hidcote roses

For the roses, use the No 4 round brush and Purple Madder, Smoked Pearl and Warm White. All three roses are painted in the same colours. The rose on the right has more of the second colour value showing for shadow, while the centre rose has the third colour value on all petals because it is in full light. Look at the two bottom petals of the opened buds. Note how the one on the left has three colour values and a bright highlight while the petal on the right has only the second colour value.

First colour value: Mix Smoked Pearl and Purple Madder (2:1) and pull this colour in from the edge of the petals, following the directional lines on the pattern. Leave touches of the background colour showing for the separations.

Second colour value: Using a dirty brush of the first colour value, pick up a touch of Warm White and mix the two colours together on your palette. Paint this mix onto all the petals, allowing the first colour value to show at the base of the petals as your shadow.

Third colour value: Using a dirty brush of the second colour value, pick up a larger amount of Warm White and paint this light colour onto the petals in the light areas.

Painting tip: Always paint following the direction and contours of the petals.

Highlight: Paint creamy Warm White onto the centre of each petal, adding a dib-dab narrow line around the shape of the petal.

Outlining: Outline the edges of the front petals with a No 1 mini liner and creamy Warm White.

Blush shadow: Apply a blush of watery Purple Madder with your dagger brush to the base of those petals on the shadow side of each rose.

Dib-dabbed centres: Touch the centre of each rose with Purple Madder to give it a red heart.

Ghostly highlight: With your dagger brush apply a ghostly highlight of watery Warm White on the left front of the roses.

Final shadows: When you have finished painting your bouquet, add shadows of watery Burnt Umber with your dagger brush. Shade under the petals and behind the roses, down the sides of the striped paper, behind the loops of the bow and ribbon and at the base of the leaves. Remember you can't have shadow until you have light, so you must have all the light areas painted in before you can apply these final soft shadows.

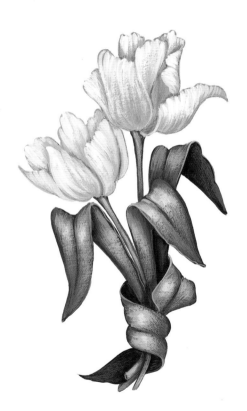

British Bouquet

From Deborah:

'Having seen the national flowers of England, Scotland, Wales and Ireland on various coats of arms, I was inspired to paint them together, but in an informal, naturalistic way. The roses are David Austen varieties from my garden. Their multi-petalled structure looks difficult to paint but it's not as intimidating as it appears. Daffodils are the other large elements in the composition. The Scotch thistles add a complementary colour element to the yellow daffodils and their spiky leaves provide a contrast in texture to the other smooth flowers and foliage. With their heart-shaped leaves, the little Irish shamrocks are perfect folk art motifs and fun to paint.'

Paints

Background colours: Naples Yellow Hue, Yellow Deep, Warm White

Decorating colours: Brown Madder, Carbon Black, Fawn, Gold Oxide, Hookers Green, Naples Yellow Hue, Olive Green, Permanent Alizarine, Pine Green, Purple Madder, Brilliant Violet, Raw Sienna, Titanium White, Unbleached Titanium, Warm White

Mediums: Jo Sonja's Stroke and Blending Medium, Jo Sonja's Retarder and Antiquing Medium

INSTRUCTIONS

Preparing the scumbled background

Basepaint the piece with Naples Yellow Hue and allow to dry. If you look at the painting you will see I have created a soft background with a light source at the top right. The darkest area is therefore at bottom left. The transition from light to dark is gradual. To create this effect, I have used a technique called scumbling. (Christine calls it 'slip-slap'.) This technique is used a great deal in the fine arts.

Wet the surface with a clean flat brush and either water or a little Retarder. Blot excess with a clean cloth. Use the imaginary diagonal line method described on page 9. You will need the flat brush for this background. Colour is applied in a criss-cross fashion. I tend to make the strokes in threes—first the two criss-cross strokes, then a vertical stroke over

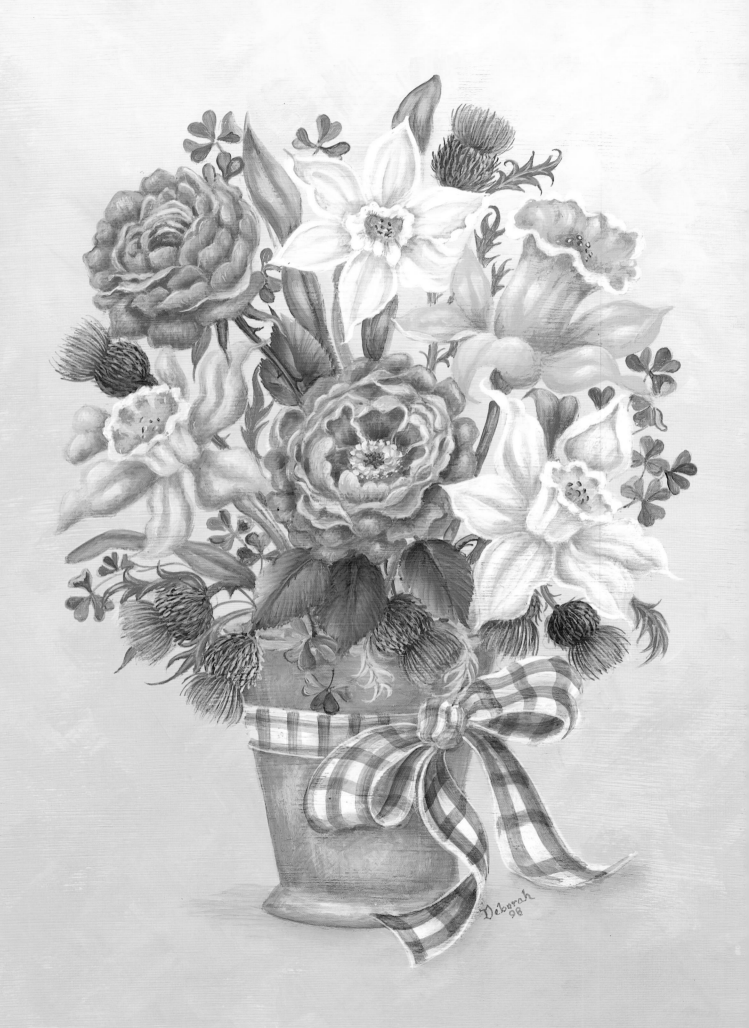

the top. Work quickly and don't try to be neat.

Load a flat brush about ½ in (12 mm) wide with Naples Yellow Hue, then brush-mix some Warm White. Start at the top right corner and scumble your way down, working the colour parallel to your imaginary line. As you reach the area around the 'line', ease off. Start from the bottom left corner with Naples Yellow Hue and Yellow Deep in your brush and work upward on the diagonal, progressing towards the imaginary line.

Ensure the background is thoroughly dry, particularly if you have used Retarder. Now lightly transfer the pattern with grey graphite transfer paper. Keep the lines very light for the daffodils or they will be difficult to cover. If you think you will need to retrace the rose petals later, leave your pattern firmly attached at the top with Scotch Magic Tape and simply fold it back while you paint.

General hints for flowers and leaves

Don't complete just one flower at a time. If you have a certain colour on your brush, paint all those areas. You can easily overwork one element if you fiddle with it for too long. You will gain a better perspective on your painting, if you keep 'on the move'. One flower does not have to be finished before you move to the next! Of course, in writing instructions I have to set things out systematically, but that doesn't mean you need to paint in that strict order.

Rose leaves

I paint my rose leaves in a variation of a method taught to me by talented American artist, Delane Lange, in the late 1980s. It's quick, easy and very effective once you get the hang of it. I call these my '30-second leaves' because they are so quick. The process of loading and blending the paint takes longer than actually painting them! The main pitfall is allowing the leaves to become too fat at the bottom or losing the shape altogether. Avoid leaves in the shape of Christmas trees! Gather some real rose leaves and put them on your worktable. Remember to stay within the pattern lines.

Doubleloading for leaves

Use a flat brush appropriate to the size of the leaf. The brush should be about half the width of the leaf at its widest point. For these leaves a ⅜ or

½ in (10–12 mm) flat brush will work well. Wet the brush with water, Retarder or Stroke and Blending Medium—whichever you like best. Blot excess. Don't overdo the wetting agent—less is better. Load the brush with a light leaf colour on one corner and a dark colour on the other. You will find suggestions on page 53. Be generous when you load the colours. Then blend on a hard surface such as a tile until the two colours join together in the middle. If the brush is dragging, dip carefully into your wetting agent. You may also need to add extra paint. Always blend again each time you add paint. And it's best to blend in the same spot on the palette each time—you won't waste paint.

Painting the leaves

Doubleload your flat brush as described. Start with the left side of the leaf and begin at the stem end. Place the brush at a 45° angle in line with the bottom of the left side of the leaf and have the light colour facing away from you while the dark colour faces the stem. Wiggle the brush back and forth as you move towards the top of the leaf. The 'wiggles' create a veined effect. You will need to press down at the widest part and angle the brush onto the chisel edge as you reach the point of the leaf.

At the very top of the leaf, the chisel edge of the brush should be vertical, that is, in line with the centre vein of the leaf. The light colour will face 12 o'clock and the dark 6 o'clock. Now, turn the brush so that the light colour faces towards you (6 o'clock) and the dark colour is at 12 o'clock. Work down the other side of the leaf using a wiggling motion. As you approach the stem end of the leaf, start to work more on the chisel edge of the brush.

Note: For a different effect, you can commence with the dark colour away from you. This places the light source on the other side. Experiment for yourself.

Painting tip: When choosing a brush for doubleloaded leaves, try this rule of thumb—the width of the brush should be approximately half the width of the leaf at its widest part.

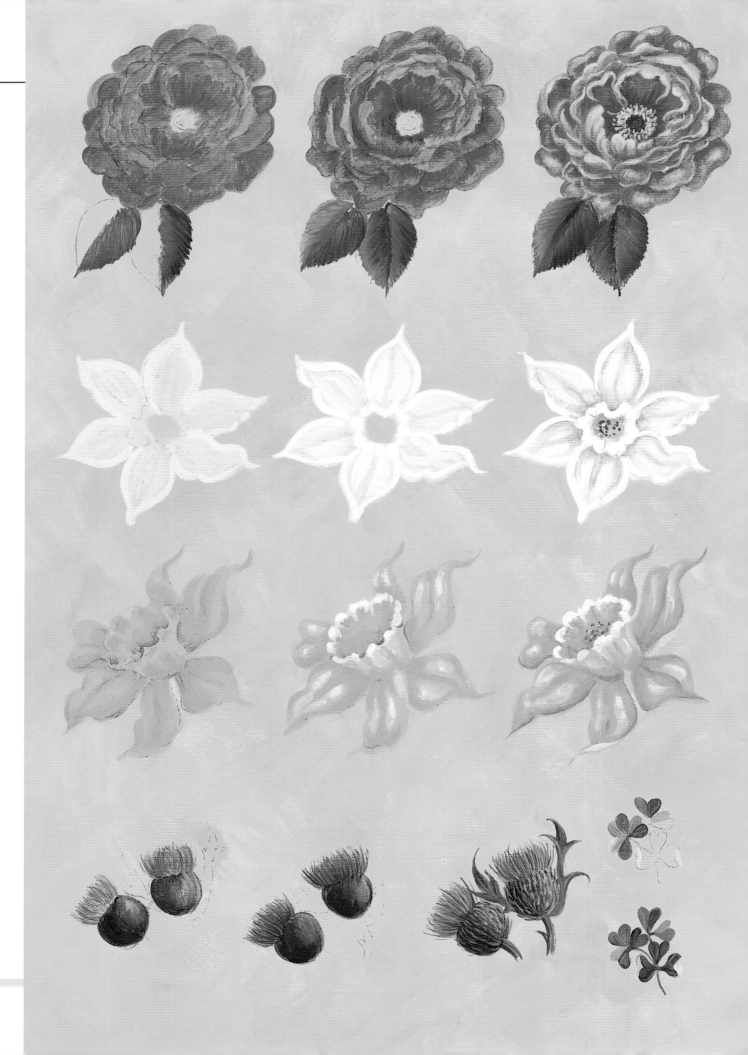

> *Painting tip:* **Leaf colour suggestions**
>
> *Light colour:* Turners Yellow, Naples Yellow Hue, Warm White or any combinations of these
>
> *Dark colours:* Pine Green, Olive Green, Hookers Green or any of these greens plus a touch of Carbon Black

Let the leaf dry. I usually repeat the process on each leaf at least once. When dry, use the flat brush on its chisel edge to paint a central vein coming up from the stem. Use a dark leaf colour with Carbon Black added.

> *Painting tip:* Remember to paint the underlying leaves first. They will be darkest.

Roses

Basepainting and shading: Base the roses with slightly watery Permanent Alizarine. Apply this petal by petal, laying down the paint to follow the curve of each petal. Deepen the area at the base of each petal with a watery mix of Brown Madder and Permanent Alizarine. Then place the very darkest shadows of this mix plus a touch of Purple Madder. You can either float this on with a sideloaded flat brush or pat in the shadow with a round brush and a touch of Stroke and Blending Medium.

Highlights: Highlight the petals with Permanent Alizarine plus Naples Yellow Hue. Add light-value highlights of this mix plus Warm White on a few petals and any turned edges. Finally, highlight the turned edges with almost straight Warm White. Allow to dry. If your highlights are too stark, paint over them with a No 4 or 5 round brush and a 'magic wash' of Permanent Alizarine plus Brown Madder. Aim to subdue the highlights rather than lose them altogether.

Centre: Paint the centre on the main rose with dots of Brown Earth. When dry, place dots of Turners Yellow and Warm White around it.

Yellow daffodils

Basepaint with watery Yellow Deep. When dry, sideload a flat brush with Raw Sienna and float shadows of Raw Sienna. If they are too strong, soften them with Yellow Deep. Paint highlights of Yellow Deep plus Warm White on the petals and the frilly edge of the throat. Build up the highlights by

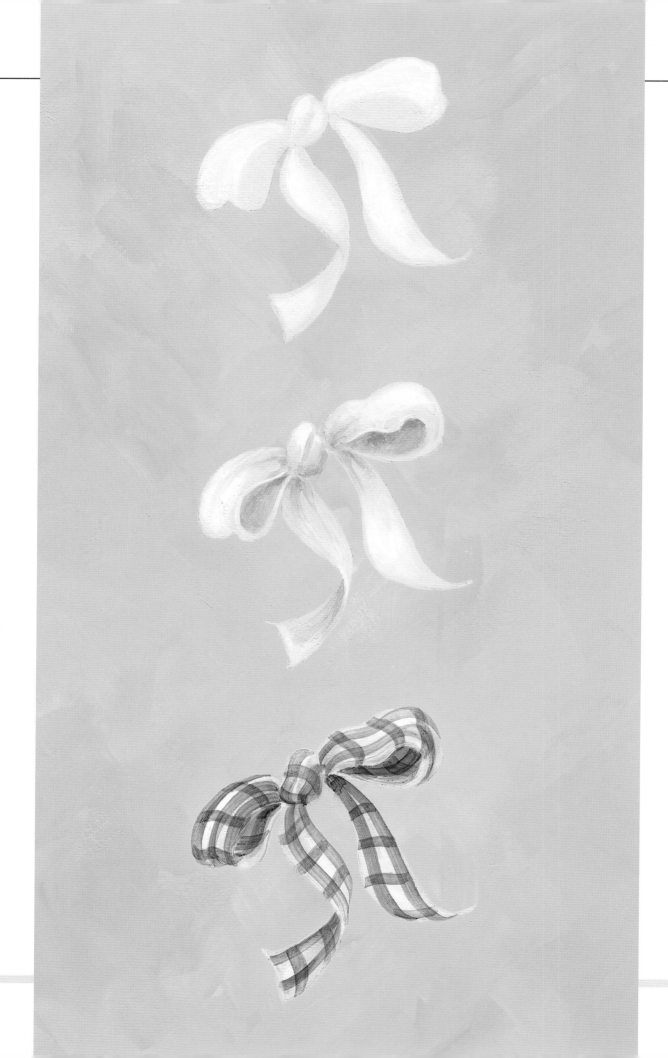

adding extra Warm White. Highlight the frilly edge with straight Warm White. Float sideloaded Gold Oxide in the throat and in some of the shadow areas. Place tiny doubleloaded dots of Pine Green and Unbleached Titanium in the throat.

White daffodils

Base the white daffodils with watery Unbleached Titanium, allowing a little of the yellow base colour to glow through. Use straight Unbleached Titanium to outline the edges of the petals and to accentuate the frilly edge of the throat. Build up highlight areas with Warm White. Accentuate the turned and frilly edges with Titanium White and outline the petals with this colour. Paint soft floats of verdigris green (Unbleached Titanium and Hookers Green) in the folds and other shadow areas as well as in the throat. Deepen the shadows under the curled edges. Paint the throat with watery Yellow Deep. Paint the stamens, doubleloaded with the verdigris green mix and Hookers Green.

Assessing the daffodils

Now assess your daffodils, particularly the white ones. Is there enough contrast? Do the highlights need raising? Do the shadows require deepening? Or are they too strong? If so, paint a wash of the base colour (Yellow Deep or Unbleached Titanium) over the shadows to soften them.

Daffodil leaves

Block in the leaves with Hookers Green and allow to dry. Build up progressively lighter highlights by adding Naples Yellow Hue to the green. Leave the central vein dark.

Scotch thistle

Stamens: Base the purple for the stamens with Brilliant Violet, using an old flat brush or a rake/comb brush. Mix a little Flow Medium with the paint if desired. Pull the strokes out from the base. Repeat with Dioxazine Purple. With a liner brush paint fine strokes of Brilliant Violet plus Unbleached Titanium. Ensure your strokes are curved to create the shape. Finally add a few strokes with a dirty brush and Unbleached Titanium, particularly on the highlight side.

Calyx: Base the calyx in Pine Green. As you block in, blend Naples Yellow Hue into the highlight side. Shade the other side with Pine Green plus a touch of Carbon Black. When dry, paint fine strokes with a mix of Pine Green plus Turners Yellow using a liner brush. On the highlight side paint a few strokes with a dirty brush and Naples Yellow Hue. Add some fine Pine Green strokes coming out from the outside edges of the calyx.

Thistle leaves and stem: Paint the stems with doubleloaded Pine Green and Brown Earth, using a round brush. Highlight one side by adding Unbleached Titanium to the mix. Don't forget to paint some thorns—the thistle symbolises retaliation. The leaves are a mix of Pine Green and Unbleached Titanium. Add veining as desired.

Shamrocks

The shamrocks consist of trios of hearts. Base each half of the little heart in a slightly different green by brush-mixing your colour, using different mixes of Hookers Green and Naples Yellow Hue. Add extra Naples Yellow Hue for the curled edges. Paint fine stems of Hookers Green with a liner brush.

Pot

I painted this pot several different ways over several days before I was happy with it. Finally I decided on a wash of Raw Sienna over the original scumbled background, leaving the centre area with some of the base colour showing through as a highlight.

Shading and verdigris on pot: When dry, dry-brush just a small amount of verdigris colour, made with Naples Yellow Hue and Hookers Green. With a sideloaded flat brush, float Raw Sienna around the edges and reinforce this with a subtle float of Gold Oxide on the left side only.

Ribbon

Like the pot, the ribbon didn't work on the first attempt either. I made the tartan too fussy. The trick is not to add to much detail. Base the ribbon with Unbleached Titanium. You will need several coats for good coverage.

Shading and highlighting: When dry, paint a wash of Warm White over the top. On the widest areas and the top of the knot paint extra Warm White to form highlights. This time, don't water down the white. Finally add the

lightest value highlights of Titanium White on the very shiniest parts. With a sideloaded flat brush, float a shadow of Fawn inside the loops, at the bottom of the knot and so on. Reinforce the shadow with a touch of watery Raw Sienna. Your highlights and shadows can be quite strong. Once the stripe pattern is painted over the top, it will serve to subdue them. Allow to dry.

Stripes: Take a small flat brush of the same width as the stripes. I used a No 2 flat. Make a mix of watery Hookers Green and test the stripes on paper. If they are too watery, blot the excess on a tissue; too dry, add extra water to the brush. Paint the transparent green stripes following the curves of the ribbon. Allow to dry. Repeat with watery Permanent Alizarine to form the pink stripes. Where the pink stripes overlap the green, the underlying green should be visible. Finely outline the ribbon with Warm White to neaten up the edges.

Shadows in foreground

With a sideloaded flat brush, float soft Gold Oxide shadows under the pot and where the ribbon trails onto the foreground.

Design and colour notes

In designing this bouquet, the size of the book page dictated the composition to some extent. Ideally, odd numbers of a specific flower work best—trios of roses, trios of daffodils—rather than two roses, two white daffodils, two yellow daffodils. The top right daffodil should probably have been a rose—but then I would have been left with one stray yellow daffodil, with no other yellow in the arrangement except the background. The stripes on the ribbon use the leaf and rose colours to unify the design and bring some of the flower colours onto the bottom third of the painting. Note that the pot is about a third of the height of the total arrangement.

Gateway

From Christine:

'As I walked down the paths and steps hidden between historic houses and gardens in an English village, I just couldn't stop thinking of the lives of the people who once walked along those passageways and through the gateways. I wonder what they would think of me.'

Paints

Background colour: Soft White—I have used Soft White but you could paint the background in any colour to suit your décor. Try French Blue and Smoked Pearl, slip-slapped together.

Decorating colours: Burgundy, Burnt Umber, Carbon Black, Dioxazine Purple, Napthol Crimson, Pine Green, Provincial Beige, Red Earth, Sap Green, Sapphire Blue, Skin Tone Base, Smoked Pearl, Warm White, Yellow Light

INSTRUCTIONS

Background of garden scene

This must be Soft White as the background is used as light glowing through the green foliage.

Yellow glow

Load a ½ in (12 mm) dagger brush with watery Yellow Light and wipe both sides of the brush before you slip-slap the centre of the scene.

Blue sky

Load the ½ in (12 mm) dagger with watery Sapphire Blue and wipe both sides of the brush before slip-slapping in the top right and left corners.

Green foliage

Load a No 4 round brush with watery Pine Green and wipe both sides of the brush. Then dib-dab softly here and there to create foliage. The stronger the foliage, the less water you will need in your paint.

Christine W.
©99.

Don't block in the foliage in an opaque manner. Try to make the background subtle. The strongest foliage is at the bottom and on the rose trellis.

Roses on trellis

For the roses, use Skin Tone Base, Napthol Crimson, Warm White and a No 2 round brush.

Swirl Skin Tone Base around to form the shape of a rose.

Highlighted petals: Tip into Warm White and pull this around those petals hanging under the trellis.

Red centres of roses: Tip into Napthol Crimson and dib-dab the centres of the roses. Do the same here and there between the roses so that you have touches of red over the trellis.

Green leaves around roses: Using a No 2 round brush and creamy Pine Green, paint leaves around each rose and leaves coming out from the trellis.

Highlighted leaves: Using a dirty brush of Pine Green, tip into Warm White and mix a pale green. Paint a few highlighted leaves.

Trellis at back of scene

Green foliage: Dib-dab watery Pine Green over the trellis.

Shades of pink: Dib-dab Skin Tone Base over the trellis. Then, using a dirty brush, pick up a small amount of Napthol Crimson, mix the two colours and dib-dab over the trellis. With a dirty brush containing the previous mix of Skin Tone Base and Napthol Crimson, pick up Warm White and mix to make a pale pink. Dib-dab here and there over the trellis.

Columns and pathway

Use Provincial Beige, Burnt Umber, Carbon Black, Warm White and Yellow Light.

First colour value: Mix Provincial Beige with a touch of Burnt Umber and block in the columns and pathway with a No 4 filbert brush. Paint only one coat.

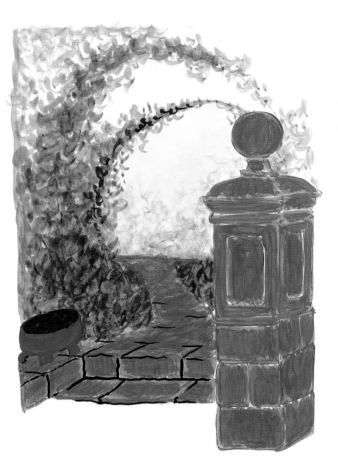
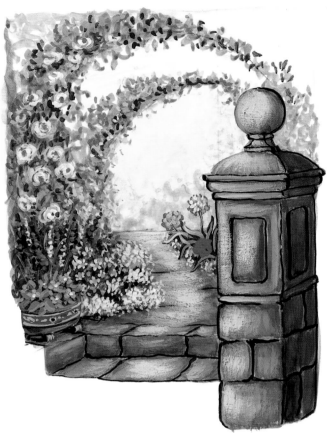

Using creamy Carbon Black and a No 2 round brush, paint between the stone blocks and outline the outside edge of the columns. Try not to paint lines of even thickness—make the lines alternately thick and thin.

Second colour value: Using a dirty brush of the first colour value, pick up Warm White, mix the two colours together and dib-dab this lighter value between the Carbon Black lines, using the filbert brush.

Third colour value: Using a dirty brush containing the second colour value, pick up Warm White again, mix the two colours together and dib-dab within the centre of each stone block.

Blush: With the ½ in (12 mm) dagger brush, paint a soft blush of watery Yellow Light onto the inside of the left column and onto the centre of the pathway.

Green mould: Using watery Pine Green and the No 4 filbert brush, scrub the green onto some of the corners of the stone blocks, onto the sides of the path and also in the corners of the steps.

Agapanthus leaves
First colour value: Using a No 2 round brush and creamy Pine Green, paint all the agapanthus leaves. While you have the green on your brush, dib-dab Pine Green around the garden.

Second colour value: Using a dirty brush of Pine Green, pick up Warm White, mix together and paint some of the leaves in this second colour value.

Third colour value: Using a dirty brush of the second colour value, pick up Warm White, mix and paint on just a few of the leaves in front.

Agapanthus flowers
With the No 2 round brush, dib-dab Sapphire Blue in the shape of a circle. Paint only one coat. Then, with a dirty brush of Sapphire Blue, pick up Warm White and dib-dab dots here and there. Highlight with just a few dib-dabs of Warm White.

White daisies
Use the No 1 mini liner brush. Paint the centre with a dot of Yellow Oxide, then paint Warm White dots around the centre.

White flowers at left in garden
Firstly dib-dab the foliage with Pine Green and let dry. Then paint the flowers by dib-dabbing creamy Warm White to suggest clusters of white flowers.

Purple lupins
With a No 1 mini liner brush and creamy Dioxazine Purple, dib-dab up from the base of the flower to form a spire shape.

White lupins
Paint the white lupins the same way but use creamy Warm White.

Terracotta pot

Block in the pot with the No 2 round brush and a mix of Red Earth and a touch of Carbon Black. Using a dirty brush of this mix, tip into Warm White, mix the colours to a paler colour and paint the pattern on the pot as well as the feet. Using creamy Carbon Black, lightly paint around the pattern on the pot.

Flowers in pot

Leaves: Mix Pine Green and Warm White (2:1) and paint the leaves. Lightly outline one side of each leaf with a paler green made by using a dirty brush of the leaf colour and then picking up Warm White.

Pink flowers: With a mix of Warm White and Napthol Crimson (2:1), paint four petals to each flower. To highlight, use a dirty brush of the petal colour and pick up Warm White. Mix the colours together and dab here and there onto the petals. The centres are Warm White.

Magnolias

Use the No 4 filbert brush and Pine Green, Warm White, Yellow Oxide, Smoked Pearl, Burnt Umber and Burgundy.

Magnolia leaves

First colour value: Block in the top of the leaf, using the No 4 filbert brush, with two coats of creamy Pine Green, allowing each coat to dry.

Second colour value: Using a dirty brush containing Pine Green, pick up Warm White, mix the two colours together and paint the veins. Pull the colour between the veins, leaving the blocked-in colour showing each side of the vein.

Third colour value: Using a dirty brush of the second colour value, pick up Warm White, mix the colours together and paint this within the centre of the second colour value and onto the light side of the veins.

Highlight: Lightly paint Warm White on one side of the leaf.

Calyx and underside of leaves

First colour value: Mix Yellow Oxide and a touch of Pine Green and paint the calyx, pulling down from the top.

Second colour value: With a dirty brush of the calyx colour, pick up Warm White and paint this mix onto the front of the calyx.

Third colour value: With a dirty brush of the second colour value, pick up Warm White and paint this mix within the centre of the second colour value.

 Under the leaves, using the same colour as the calyx and the same three colour values, pull your colours in from the edge of the leaves and into the centre vein.

Magnolia flowers

First colour value: Mix Smoked Pearl and Burgundy (4:1) and block in the magnolias with your No 4 round brush.

Second colour value: Using a dirty brush of the first mix, pick up a generous amount of Warm White and pull this down from the top of the petals and folds, leaving the blocked-in colour on the inside of the flowers.

Base of petals: Using the No 4 round brush pull creamy Burgundy up from the base of the petals. When dry, repeat the Burgundy but don't pull this second layer up as far as the first one.

Blush highlight: Using your ½ in (12 mm) dagger brush, blush watery Warm White onto the join of the pink and burgundy petals.

Lace and Castles

> For a man's house is his castle, and each man's home is his safest refuge.
> SIR EDWARD COKE (1552–1634)

From Deborah:

'This design is inspired by Britain's own folk painting style known as "Roses and Castles". In a traditional design, the castle scene is framed by a wreath of stylised roses and daisies. I have taken a very different approach, using lace instead of flowers. The lace pattern is loosely adapted from a piece of old Nottingham lace given to me by my friend and lace collector extraordinaire, Sue Hampson.

'I have also taken liberties with the colours used in the castle vignette. Traditional canalboat painters use bright primary hues whereas the colours in this scene are soft and subdued.

'There are lots of wonderful books for those who want to paint in the traditional way. I particularly recommend Flowers Afloat and Narrow Boat Painting *by A. J. Lewery and* Paint Roses and Castles *by Anne Young (both David and Charles).'*

Paints

Background colour: Very dark blue such as Galaxy Blue or Storm Blue

Decorating colours: Aqua, Brown Earth, Carbon Black, French Blue, Moss Green, Pine Green, Raw Sienna, Turners Yellow, Warm White

Mediums: Jo Sonja's Flow Medium

Canalboat painting

'Roses and Castles' painting originated in the nineteenth century and was used to decorate the exteriors and interiors of canalboats (narrowboats). Castles are essential subject matter in this art form but nobody quite knows why. It is easy to imagine that the boatmen, plying their way past the ruined castles which dot the English countryside, dreamed of magical castles as the ultimate place to live. This would have been a natural reaction to living in tiny, cramped quarters, literally like sardines. The boatmen and their families were staunchly house-proud, keeping everything neat as a pin: doilies on shelves, souvenir plates and bric-a-brac on walls (where they would not take up valuable space) and, of course, handpainted utensils everywhere—but only practical objects such as buckets, watering cans, cupboards and trays.

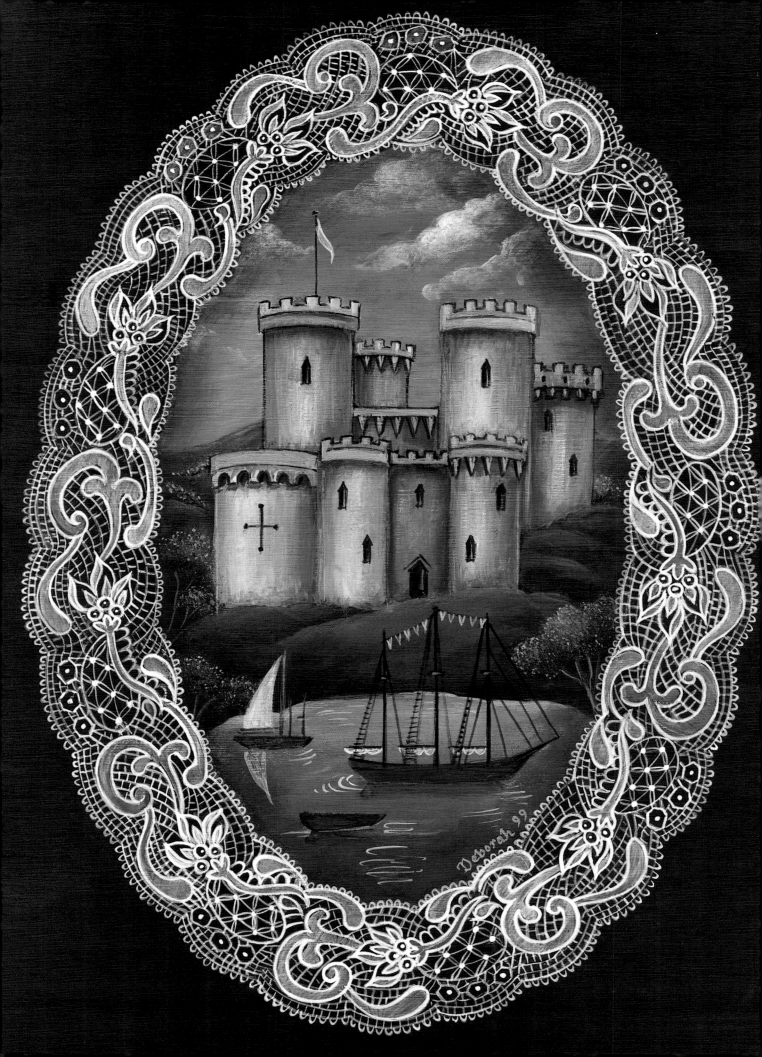

Preparation

Basecoat with Galaxy Blue, Storm Blue or a similar dark blue. This will provide good contrast with the lace design. Transfer the lace pattern with white transfer paper. Only transfer the very basic outlines for the lace and paint the rest freehand. If you have lots of white pattern lines behind the lace, it will only confuse you—it's hard to see how fine your painted lines are when the pattern lines are underneath. It's best to have as much sharp, dark background as possible. You may need to reapply the boat and castle details later.

Painting the scene

There are no real rules to painting the scene so feel free to experiment with different methods, colours and brushes. Apply thin layers of colour to block in the various areas and build up the layers as you go. Use your dark background to create shadows. All general work can be done with your favourite round brush. A large round or a flat brush is ideal for applying colour to large areas. For shading and highlighting, try sideloading a ½ in (12 mm) flat brush. Detailed work can be done with a liner brush.

As a folk artist, I've taken liberties with reality to romanticise the scene. As discussed earlier, the colours I've used are softer than the usual primary hues favoured by traditional canal boat painters.

Painting tip: Remember that the sky always appear lightest at the horizon.

Sky

Block in the sky with a mix of Warm White, French Blue and Aqua. Mix with water or Flow Medium to make it semi-transparent. Start at the horizon where the colour should be lightest and most opaque. As you reach the top of the sky, use less white and more of the blues to give a more transparent look. Apply the paint horizontally from one side of the sky to the other and try to smooth out brushmarks. Don't worry if the blue goes onto the hills or castle but keep it off the lace area. Let the first coat dry and then repeat for better coverage and depth of colour.

Clouds

When dry, paint the clouds. Use a small flat brush, sideloaded with a mix of Warm White and a touch of the sky colour (so that the white is not too

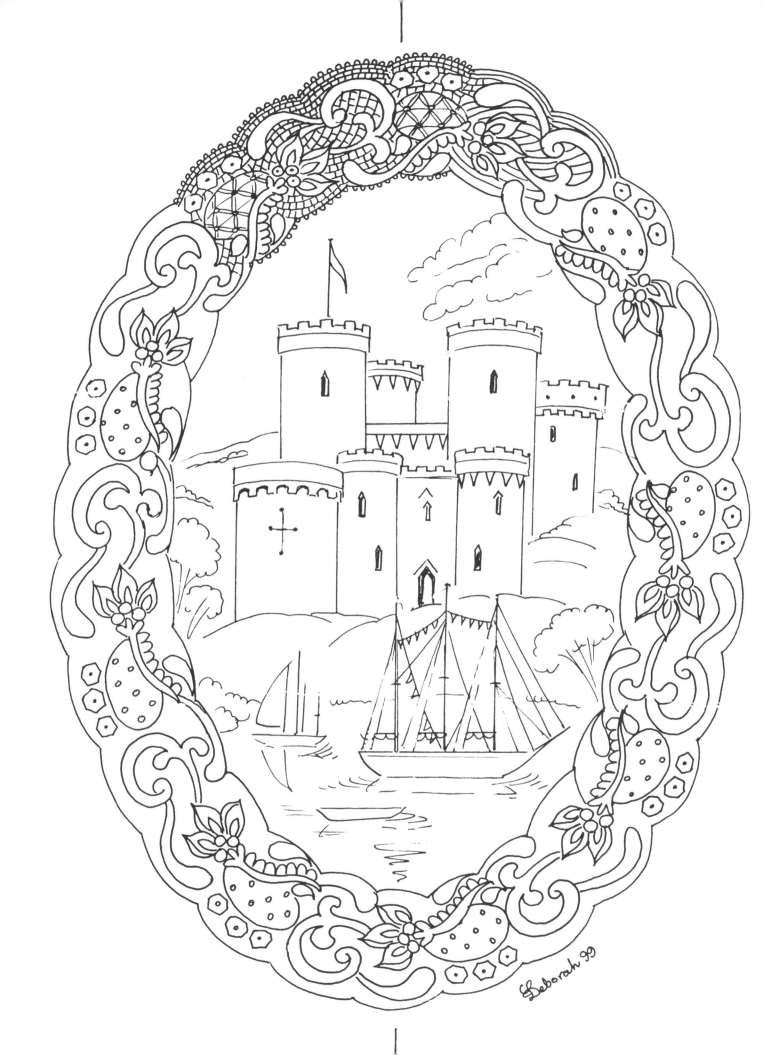

stark). Give some clouds a second coat. Don't paint too many clouds or your sky will look cluttered. Soften the edges with your finger or a cotton bud. Play with the clouds until you're happy with them.

Water

Paint the water in the same way as the sky but start at the shoreline. Add ripples and reflections after you paint the boats.

Hills and midground

Block in with Olive Green and a touch of Flow Medium to keep the colour a little transparent. Work horizontally, following the curves of the hills. Allow more of the dark blue background to show through in the hollows. When dry, load a flat brush with Olive Green and sideload with Moss Green. Run some highlights on the tops of the hills and on curves where the light would hit.

Creating the trees and foliage

Use a small piece of damp sponge to create the foliage on the trees and bushes. Always wipe your sponge across a piece of paper towel after loading to spread the colour and remove excess. Begin with Pine Green. Then highlight the tops with Moss Green, then Turners Yellow. Use a dirty sponge—don't wash it between colours. Shade by sponging on Pine Green plus a touch of Carbon Black at the base of the foliage. With a liner brush, paint trunks and branches in doubleloaded Brown Earth and Raw Sienna.

Castle

This castle is a simplified and stylised version of the wonderful Castle Conwy in North Wales, built in the thirteenth century by Edward I, who was also responsible for Carnaervon, Harlech and Beaumaris. Conwy is a real jewel, set above a sparkling harbour and very much the epitome of the mediaeval fortress castle.

Block in the castle with a light grey made from Warm White plus Carbon Black. Brush-mix some shading and highlights as you go by varying the mix. Allow to dry and repeat. Build up Warm White highlights at the centre of each rounded tower. Blend these wet-in-wet or dry-brush them on. Allow the highlights to dry. Now you can retransfer the details or sketch them on

with a chalk pencil. When dry, float dark grey shadows on the walls and under the castellations, ramparts and battlements. Paint windows and the door Brown Earth with a touch of Carbon Black. Leave a little highlight of the grey basecoat unpainted in each.

Boats

The boats are very stylised—adapt to suit yourself. Paint the hulls with Brown Earth and the masts and rigging with a mix of Carbon Black and

Brown Earth. Use Flow Medium to keep your lines fine (see the box: Ten tips for lovely lace). Paint watery Warm White for the reflections of the sails on the water. Add Warm White ripples with your liner brush.

Floated antiquing

When you are happy with the scene, allow it to dry well, preferably overnight, then apply a thin coat of Clear Glaze Medium. Again, let the Clear Glaze Medium dry thoroughly. Wet a ½ in (12 mm) or similar flat brush with water, Retarder or Flow Medium, blot off excess, then sideload with Brown Earth. Blend the colour on your palette and float a soft shadow around the edge of the scene. Now you are ready to paint the lace.

Lace border

Lace played an important part in canalboat interiors. The wives of the boatmen crocheted cotton lace curtains, shelf trims, valances and doilies to decorate their tiny homes. However, painted lace is not a feature of canalboat painting!

Linework on lace

Before you begin, it's advisable to read the box: Ten tips for lovely lace— they are the result of many years of trial and error, including lots of errors!

Don't worry if your panels vary a little. You will notice that I had to 'fudge' the pattern on some of the sections on the oval. They are not exactly the same—some parts are stretched, others contracted.

Mix Warm White with Flow Medium to give an inky consistency and, using your liner brush, experiment until you establish the right consistency—not too runny but not too thick. Paint all the main outlines first. These will need several coats to give opaque coverage. The finer lines will need only one coat. Always roll your brush on a tissue to remove excess paint mix, otherwise you will have very thick lines.

Washes on lace

Some of the larger scrolls and flower petals are coloured in with a soft wash of Warm White. Paint these washes with a No 2 or 3 round brush. Mix Flow Medium with the white paint and blot the excess on a tissue before you start

colouring in. You need only the slightest hint of paint on your brush. When dry, do a second coat if necessary.

To antique or not to antique?

Some people antique their lace and it does give a lovely, mellow effect. My own feeling is that, as I've spent so much time painting the lace, I don't want to obscure it in any way! It's up to you but if you do choose to antique, allow the painting to dry thoroughly and always apply a pre-antiquing barrier (such as Clear Glaze Medium) beforehand and allow it to dry well, preferably overnight.

Ten tips for lovely lace

- Work in a good light.

- Don't paint lace when you're tired. You need to be fresh and relaxed to paint good lace. Take a break every ten minutes to give your eyes a rest.

- Only transfer the minimum of pattern lines. Work all the fine details freehand, keeping your pattern beside you.

- Use a good quality No 0 or similar liner brush or a very fine round brush.

- Flow Medium is the best friend of the lace painter. It will keep your lines fine and sharp.

- Have all your lace painting equipment ready—liner brush, fresh white paint, a jar lid filled with Flow Medium and a supply of tissues.

- Always load your brush by rolling it. Roll your brush in Flow Medium and in paint and then roll in a tissue to remove excess. The more mix you roll off the brush and onto the tissue, the finer the painted lines will be.

- Erase the pattern lines as soon as you have the main lines painted. But ensure the paint is thoroughly dry first!

- Don't worry if your strokes are a bit irregular—real lace has irregularities too. Remember that people will look at the lace from a distance. They will not see minor mistakes so don't get too caught up in the detail. Look at the overall effect.

- If you make a bad mistake, remove it with a damp cotton bud. Allow the area to dry before continuing.

Fruitful Abundance

From Christine:

'Loomed tapestries are a great love of mine, so when Deb and I visited Blenheim Palace in England my breath was taken away on viewing all those massive tapestries hanging on the walls. The attention to detail was overwhelming, the borders were just magnificent and the abundance of colour delectable. I will never forget them. So there you have the influences for this painting: colour, abundance, borders and my passion for detail.'

Paints

Background colour: Teal Green

Decorating colours: Burnt Sienna, Carbon Black, Indian Yellow, Napthol Red Light, Norwegian Orange, Permanent Alizarine, Pine Green, Purple Madder, Sap Green, Sapphire Blue, Smoked Pearl, Teal Green, Ultramarine, Warm White, Yellow Light, Yellow Oxide

Background

Paint the background with Teal Green using a No 4 filbert brush.

Four corners and centre oval

Paint the four corners and centre oval with a mix of Carbon Black and Sapphire (2:1). When the four corners are dry, use a dirty brush of this colour and pick up more Sapphire Blue. Mix the colours together on your palette and dib-dab the resulting colour around the flower outlines in the corners (not the centre oval), allowing the first colour value to show as a shadow next to the flowers and branch. Leave the centre oval in the first colour mix.

Branch border

First colour value: Paint with Burnt Sienna and a No 2 round brush.

Second colour value: Using a dirty brush containing Burnt Sienna, pick up Warm White and mix the two colours together on your palette. Pull this colour along the branch, crisscrossing your lines of colour here and there.

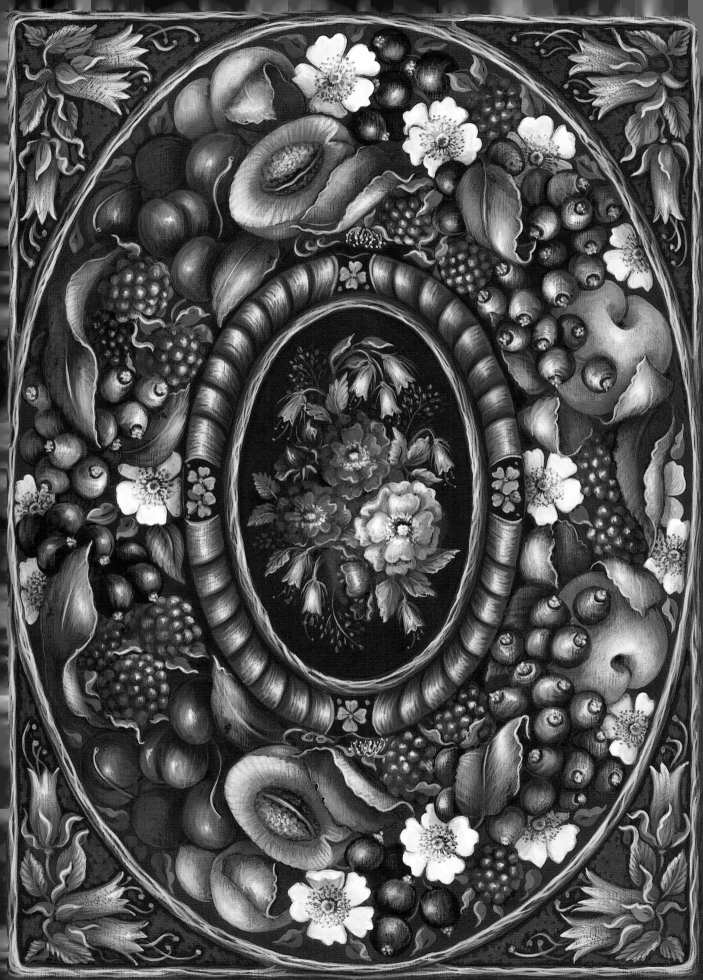

Christine D. 99 ©

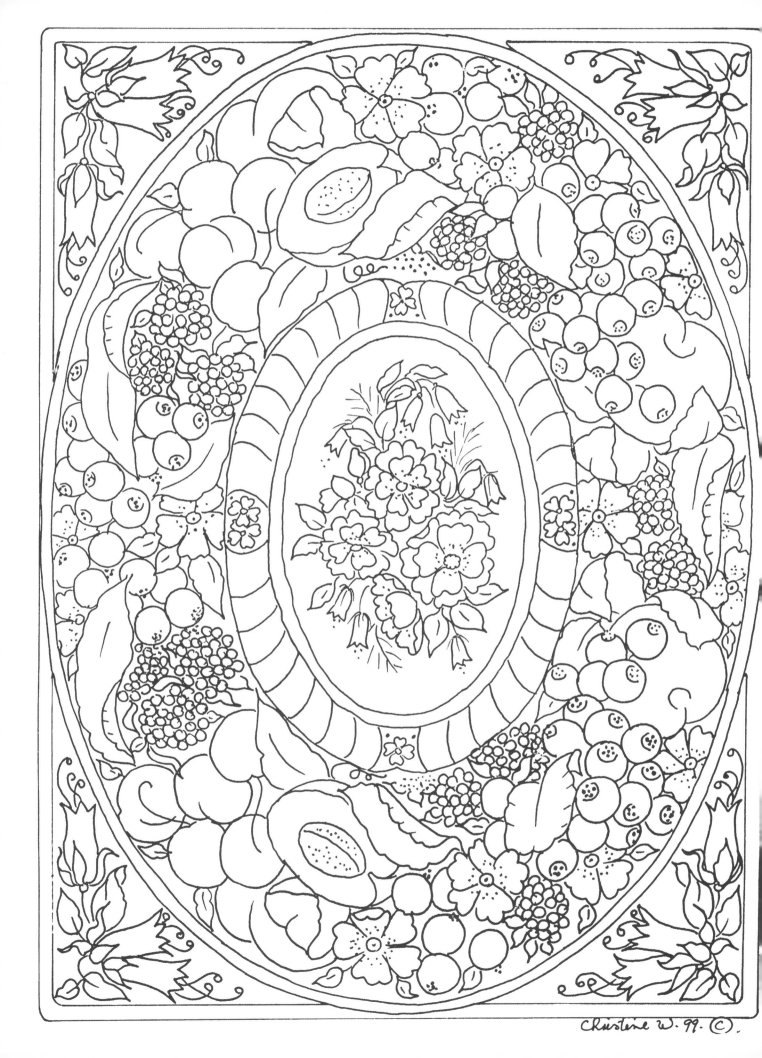

Christine W. 99. ©

Third colour value: Using a dirty brush of the second colour value, pick up Warm White and paint this highlight colour onto the inside edge and lightly over to the centre. Leave the first and second colour values showing on the shadow side.

Pleated design around oval

First colour value: Block in the pleated design around the oval with Teal Green.

Second colour value: Using a dirty brush of Teal Green, pick up Warm White and pull this colour into the shape of the pleat, leaving the first colour showing between each pleat.

Third colour value: Using a dirty brush of the second colour value, pick up Warm White and paint this highlight colour from one side of the pleat, feathering off before you come to the Teal Green left showing between each pleat.

Highlight: Paint Warm White within the third colour value.

Blue flowers inside pleated design

First colour value: Block in with Sapphire Blue and the No 2 round brush.

Second colour value: With a dirty brush of Sapphire Blue, pick up Warm White, mix together and paint this onto the petals, leaving touches of the first colour value showing.

Third colour value: With a dirty brush of the second colour value, pick up Warm White and outline the edge of each petal.

Centre: Paint a dot of Yellow Oxide, then paint dots onto the black and Sapphire Blue background.

Bluebells in corner and in centre bouquet

First colour value: Paint with Sapphire Blue.

Second colour value: With a dirty brush containing Sapphire Blue, pick up Warm White and pull this up from the edge of the petal, feathering off at the base of the flower.

Third colour value: With a dirty brush of the second colour value, pick up Warm White and paint this colour but don't come down as far this time.

Highlight: Paint Warm White within the third colour value. Lightly outline the peaks of the petals.

Stamens: Using a dirty brush of Pine Green, pick up Warm White, mix the colours together and paint the stems for the seeds.

Seeds: Paint Yellow Oxide dots at the end of the stem.

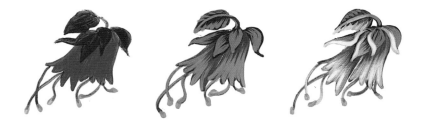

Bluebell leaves

The leaves for the bluebells and the leaves throughout the design are the same.

First colour value: Block in the leaves with Pine Green.

Second colour value: Using a dirty brush of Pine Green, pick up Warm White, mix the two colours together and pull this in from the edge, allowing the Pine Green to show behind the folds of the larger leaves.

Third colour value: Using a dirty brush of the second colour value, pick up Warm White, mix the colours and paint the vein first. Then pull in from the edge but this time cover less of the leaf.

First blush: Apply a blush of watery Pine Green with the ½ in (12 mm) dagger brush.

Second blush: Blush watery Burnt Sienna in the shadows.

Highlight: Paint Warm White within the third colour value and lightly on the vein. Outline one edge of each leaf with this colour.

Cherries

Block in the cherries with Permanent Alizarine and the No 4 filbert brush. Create the shape of the cherry using Warm White but leave the Permanent Alizarine showing between the cherries. Don't paint the Permanent Alizarine solidly—this is a wispy coverage. Finally paint a thick wash of Permanent Alizarine over the cherries.

> **Painting tip:** A thick wash is a semi-transparent mix with more paint and less water than a standard wash.

Highlight: Highlight each cherry with a dab of Warm White.

Apricots

For the apricots, use your No 4 filbert brush and Yellow Oxide, Norwegian Orange, Burnt Umber, Warm White, Permanent Alizarine and Indian Yellow.

First colour value: Paint the skin of the apricot with one coat of Yellow Oxide.

Second colour value: Using a dirty brush of Yellow Oxide, pick up Warm White and scrub this colour onto the apricot.

Third colour value: With a dirty brush of the second colour value, pick up Warm White and scrub this in a smaller area (the highlighted areas).

Highlight: Scrub Warm White onto the highlight area.

Blush: Apply a blush of watery Indian Yellow with your dagger brush. Don't cover all of the highlight.

Halved apricot

Don't scrub the paint onto the sliced area. Instead, using the three colour values, pull each value in from the edge of the apricot, leaving lines of the Yellow Oxide showing. Feather off your paint before reaching the stone.

Blush: Apply a blush of watery Indian Yellow on the shadow side. Then, using watery Permanent Alizarine and your dagger brush, paint a blush around the stone. With the tip of the dagger, pull out a few lines from the stone.

Apricot stone

Block in the apricot stone with Burnt Umber and the No 4 round brush. Then, using a dirty brush of Burnt Umber, pick up Warm White and dib-dab the resulting colour onto the stone. Build up to the third colour value.

Highlight: Highlight by dib-dabbing with Warm White.

Blackberries

For the blackberries, use your No 4 round brush and Carbon Black, Sapphire Blue, Warm White, Ultramarine and Permanent Alizarine.

First colour value: Block in with a mix of Carbon Black and Sapphire Blue (2:1).

Second colour value: Paint the circles on the blackberry with Sapphire Blue. Ensure that you leave the blocked-in colour showing between the circles.

Third colour value: Using a dirty brush containing Sapphire Blue, pick up Warm White and highlight within the centre of the circle. Don't paint this paler blue on the shadow side.

First blush: Using your dagger brush, lightly blush watery Ultramarine here and there.

Second blush: Paint a blush of watery Permanent Alizarine onto the shadow side here and there. Remember to apply just touches of colour.

Highlight: When all the blushes are dry, dab a small highlight of creamy Warm White onto the light side.

White blossoms

Paint the blossoms with the No 2 round brush and Smoked Pearl, Warm White, Permanent Alizarine, Yellow Oxide and Carbon Black.

Petals: Paint all the petals with two coats of creamy Smoked Pearl, allowing each to dry.

Highlighted petals: Pull creamy Warm White over those petals in the light and leave Smoked Pearl showing in the shadows and under the folds.

Outlining: Using the No 1 mini liner brush, tip into Warm White (neat from the tube) and outline the edges of the petals.

Centre: With the No 1 mini liner brush, dib-dab Yellow Oxide in a circle to form the centre.

Seeds: With the No 1 mini liner brush, dot small seeds of Permanent Alizarine around the centre. When dry, dot Yellow Oxide seeds.

Shadow: With the liner brush, dib-dab a shadow of creamy Carbon Black halfway around the centre.

Ghostly highlight: With your dagger brush and watery Warm White, blush a ghostly highlight onto the light side of each blossom.

Blackcurrants

For the blackcurrants, use the No 4 filbert brush and Carbon Black, Warm White, Sapphire Blue and Burnt Umber.

First colour value: Block in with creamy Carbon Black.

Second colour value: Using a dirty brush of Carbon Black, pick up Warm White and mix to a pale grey. Paint from one side of each currant, leaving the other side in the blocked-in colour.

Third colour value: Using a dirty brush of the second colour value, pick up Warm White and paint within the centre of each currant.

Highlight: Dab Warm White within the centre of the third colour value.

Blush: Using watery Sapphire Blue and your dagger brush, paint a blush onto the grey and highlighted areas.

Ghostly highlight: Apply a soft blush of watery Warm White over the Sapphire Blue blush.

Dots at bottom of currants

Use your No 1 mini liner brush for the dots.

First colour value: Using a dirty brush containing Burnt Umber, pick up Warm White, mix the two colours together and paint dots to form a circle.

Second colour value: Using a dirty brush of the first colour value, pick up Warm White to form a highlight colour and paint fewer dots this time.

Purple currants

First colour value: Block in the purple currants with the No 4 filbert brush and Purple Madder.

Second colour value: When this is dry, use a dirty brush of Purple Madder and pick up Warm White and paint from one side of each currant, leaving the other side in the blocked-in colour.

Third colour value: Using a dirty brush of the second colour value, pick up Warm White and paint within the centre of each currant.

Highlight: Dab Warm White within the centre of the third colour value.

Blush: Blush each currant with watery Purple Madder and the dagger brush.

Highlight over blush: Using creamy Warm White and a No 2 round brush, paint a C-shaped highlight, curving around the base of the currant. From the centre of this C shape, paint a highlight in the shape of a tornado.

Ghostly highlight: With your dagger brush and watery Warm White, blush a ghostly highlight over the tornado shape.

Dots within the C shape

Use a No 2 round brush for these dots.

First colour value: Using a dirty brush containing Burnt Umber, pick up Warm White and paint the dots on the widest part of the 'tornado'.

Second colour value: Using a dirty brush of the second colour value, pick up Warm White and paint a few highlighted dots.

Red roses

For the red roses, use a No 2 round brush and Permanent Alizarine, Napthol Red Light, Yellow Oxide, Yellow Light and Warm White.

First colour value: Block in with one coat of Permanent Alizarine.

Second colour value: Paint each petal Napthol Red Light. Pull the paint towards the centre and allow the Permanent Alizarine to show between the petals.

Seeds: The seeds are Yellow Oxide dots forming a circle.

Highlighted seeds: Using a dirty brush of Yellow Oxide, pick up Warm White and paint the highlights onto the inside of the seed circle.

Outlining edges: Using a slightly watery Warm White, outline the edges of the petals at the centre of the bouquet.

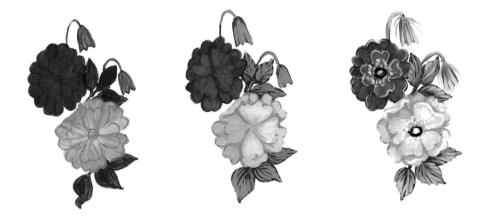

Yellow rose

First colour value: Block in with creamy Yellow Oxide, leaving touches of the background showing as separations between the petals.

Second colour value: Using a dirty brush of Yellow Oxide, pick up Warm White and paint the petals on the inside of the bouquet, leaving the Yellow Oxide petals on the shadow side.

Third colour value: With a dirty brush of the second colour value, pick up Warm White and highlight within the second colour value.

Seeds: The seeds are Warm White.

Blush: Using watery Yellow Light and your dagger brush, apply a light blush onto the yellow roses.

Blushes on red roses: While you have the Yellow Light in your dagger brush, lightly blush this colour onto the red roses through the centre of the bouquet.

Leaves

Paint the leaves Pine Green. Then, using a dirty brush of Pine Green, tip into Warm White and progressively paint the second and third colour values.

Blush on leaves: Blush the leaves with watery Sap Green and the dagger brush.

Fern

Paint Pine Green dots and stems. With a dirty brush of Pine Green, pick up a small amount of Warm White and highlight by touching this colour onto just a few of the dots. When dry, apply a Sap Green blush as for the leaves.

It's a Dog's Life

From Deborah:

'As a child, I was fascinated by the pair of Staffordshire dogs which stared down at me from my great-aunt's mantel. As an adult, I enjoy scouring antique shops for these porcelain pooches, much to the consternation of my husband and son who do not appreciate their naïve charm. Original nineteenth century dogs can fetch hundreds of dollars so this painted pair is a good alternative—they cost nothing but your time. It would be fun to enlarge these dogs and paint them as life-size cut-outs. You could sit them on a shelf or attach a wooden wedge and use them as doorstops.

'I crackled my dogs to suggest the crazing or craquelure typical of antique porcelain. The dogs are framed by a wreath of typically English flowers—wild primroses and their refined cousin, the auricula.'

Paints

Background colours: Naples Yellow Hue, Teal Green, Carbon Black

Decorating colours: Brown Earth, Carbon Black, Dioxazine Purple, Fawn, Gold Oxide, Hookers Green, Naples Yellow Hue, Pine Green, Rich Gold, Titanium White, Turners Yellow, Unbleached Titanium, Warm White, Yellow Deep

Mediums: Jo Sonja's Crackle Medium (the original top crackle, not Décor Crackle), Jo Sonja's Flow Medium

INSTRUCTIONS

Preparing the background

Firstly basecoat the piece with Naples Yellow Hue. I lightly sponged the Naples Yellow Hue background with a mix of that colour and Warm White to soften the solid look—but this is a matter of taste.

Allow to dry. Trace the pattern onto tracing paper and centre on your surface. Secure with Scotch Magic Tape. Lightly transfer the flower wreath pattern with grey transfer paper. Paint the area inside the wreath with Teal Green. Use smooth, horizontal strokes and don't allow the paint to build up around the edges.

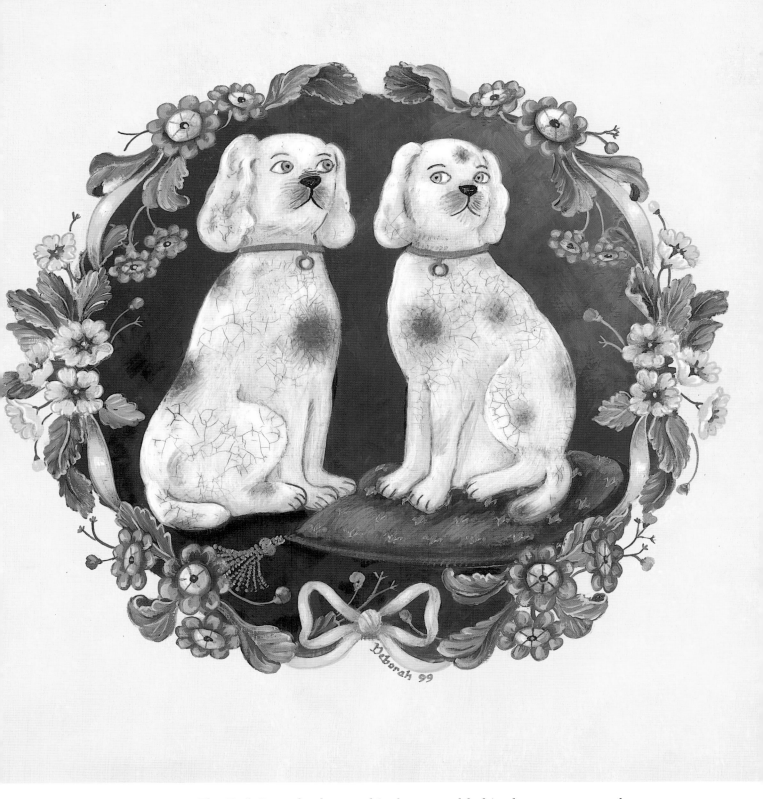

The Teal Green background is then scumbled in the same way as the British Bouquet (page 48) to create a light source. This time, add Naples Yellow Hue to the Teal Green for the light areas and a little Carbon Black to the Teal Green for the dark areas. When dry, transfer the pattern for the dogs by using white transfer paper.

Note: Throughout the painting process leave your pattern secured (but folded under at the back) in case you need to reapply details later—particularly the dogs' facial features.

Basecoating the dogs

Use a large round (such as a No 5) for all basecoating. Thin your paint a little with water or Flow Medium to make it creamy and to avoid ridges. Block in the dogs with at least two coats of Unbleached Titanium plus a touch of Fawn, allowing each coat to dry well. Then apply a few creamy coats of Warm White, leaving some shadows of the base colour showing. Finally apply highlights of Titanium White to the areas such as the forehead, back, tummy, haunches, fronts of legs, tops of ears, tail and so on. Keep building up the highlights with further coats of Titanium White to give opacity in the areas that will be lightest. When you are happy with this effect, you may wish to add very soft, floated shadows of Brown Earth between the legs, under the chin and so on.

Gold Oxide spots

If you look at the real china dogs, you'll see that these spots can be quite naïve and unrealistic. Sometimes they look like sunbursts! It's up to you. I took a safe, middle path—not too realistic but not grotesque either. One way to create the spots is to stipple them on. I used a small scruffy flat brush—make sure it is dry and that you have wiped off almost all the paint on a cloth. The Gold Oxide colour should be deeper at the centre of each spot. Feather the colour around the edges. Have very little paint on the brush at the edges of the spots.

Dogs' faces

My dogs are actually prettier than the real thing. You may want to make yours less cute. It is a tradition for them to have staring eyes and a rather vacant look.

Deepen the area under the nose and above the mouth with fine strokes of Gold Oxide or Brown Earth. There are a couple of strokes above the nose too.

Paint the eyes Warm White. Let dry. Outline with Brown Earth. The irises are watery Gold Oxide. When dry, paint a tiny black pupil.

The nose is Carbon Black with a gap of Warm White left as a highlight. The mouth is painted with Brown Earth—keep the lines fine and avoid a fish-hook mouth.

Add the final details such as the Rich Gold collar and Brown Earth linework on the paws.

Purple cushion

Now we'll paint a regal purple cushion for these pampered pooches. Basecoat the cushion in a medium purple made with Dioxazine Purple and Unbleached Titanium. When dry, highlight with a lighter version of the basecolour made by adding extra Unbleached Titanium. Shade under the pooch with straight Dioxazine Purple, with a touch of Carbon Black added if you like. Use your favourite method for shading and highlighting (see the General Tips and Techniques section). Make the contrasts quite strong as the fleur-de-lis design will tend to obscure them. Similarly, don't worry if your shading and highlighting are not perfect—when a design is applied over the top, it covers any problems. Refer to the 'tartan' ribbon in the British Bouquet project for another example of this.

Now paint tiny fleurs-de-lis with Rich Gold paint. You will need two coats. Add the Rich Gold lines for the cord and tassel.

Top crackling

You may want to leave your dogs in pristine condition as in the final step-by-step painting or you can simulate the effect of crazed china by applying Jo Sonja's Crackle Medium (not Décor Crackle) to your painted wood piece.

Avoid crackling in humid or wet weather—the results will not be as good. Of course, if you live in Sydney as I do, or a coastal area further north, this is easier said than done. The crackling in our project colour plate was done on a sultry summer's day. The effect would have been better if I had waited for ideal weather conditions, but as it was a particularly humid, rainy summer, this book might never have been finished!

Crackling is an unpredictable process and if you are new to it, please do some experiments on a sample board before you attempt a real project. Read the instructions on the bottle carefully. Try different thicknesses of Crackle Medium, and also vary the method of application—brush on the medium, pour a little over an area and so on. Once you have decided which

method works best for you, you are ready to try it on your masterpiece.

Let the Crackle Medium dry naturally and don't be tempted to touch it while it's drying—you'll make craters. When the cracks have all appeared and the surface is completely dry, accentuate the crackled effect with a mix of water (or Retarder) and Brown Earth, rubbing the mix into the cracks. Wipe off immediately with a clean, damp cloth, leaving the mixture in the cracks only.

> *Painting tip:* Do not put Crackle Medium on the dog's faces—apply it to selected body areas only.

Flower wreath

I used my all-purpose No 2/3 round brush for all the general work. Apply floated colour with a small flat brush and use a liner brush for outlining.

Primroses

Base the petals with Turners Yellow. When dry, deepen the colour by applying creamy Yellow Deep over the top. Let dry. Float Gold Oxide around the centre and where petals overlap. Highlight the petals with overstrokes of Turners Yellow plus Warm White, doubleloaded on your round brush. Finely outline the petals at random with Gold Oxide or Warm White, depending on the background colour. The star-shaped centre is Pine Green. Add a Turners Yellow dot and a smaller dot over the top of Turners Yellow plus Warm White. The stems are painted with Pine Green and a little Flow Medium.

Primrose leaves

Base the leaves with Pine Green or Hookers Green or a mix of the two. Allow to dry. Double or triple-load your round brush with combinations of the following colours: Pine Green, Hookers Green (dark colours), Turners Yellow, Naples Yellow Hue (lighter colours). Paint the leaves section by section, leaving a dark area of the base colour along the central rib of the leaf. Leave dark green showing where leaves overlap and on the underside of curled areas. You can also make one side of a leaf darker than the other by leaving the dark green showing. Paint a fine rib of Naples Yellow Hue down the centre of some leaves, add some veins and outline the edges at random.

Auricula petals

Base the petals with a medium purple mix of Dioxazine Purple plus Unbleached Titanium. Build up highlights of progressively lighter purple on each petal by adding extra Unbleached Titanium to the purple. Finish with a crescent stroke of light purple (add some Warm White to the previous highlight mix) on each petal.

Auricula centres

Paint the centre with Naples Yellow Hue. Shade with a float of Raw Sienna and highlight with a touch of Warm White. Paint a Pine Green dot in the centre and a tiny Turners Yellow dot on top. Add fine brown lines in a wheel-spoke pattern.

Auricula leaves

Paint the auricula leaves in the same way as the primrose leaves. Note their flowing scroll shapes and follow the curve of the leaf as you paint each section.

Ribbon

Base the ribbon with Turners Yellow. When dry, apply a glaze of Yellow Deep. Build up highlights of Turners Yellow plus Warm White in the wide parts. Each highlight should be lighter and smaller than the previous one. Finish with a small highlight of Warm White in the very widest part. This will make the ribbon shine. Shade the narrow and underlying areas of the ribbon with floated Gold Oxide. Outline the ribbon with Gold Oxide or Warm White. Keep your lines fine by adding Flow Medium to the paint and rolling off excess paint on a tissue.

Through the Window

From Christine:

'A still-life inspired during an afternoon tea in a mediaeval inn at Bradford-on-Avon. This was the view from the window.'

Paints

Background colour for scene: Soft White or Warm White

Background colour for border: Carbon Black

Decorating colours: Burnt Sienna, Burnt Umber, Cadmium Orange, Carbon Black, Dioxazine Purple, Pine Green, Paynes Grey, Permanent Alizarine, Provincial Beige, Purple Madder, Rich Gold, Smoked Pearl, Teal Green, Ultra Blue Deep, Warm White, Yellow Light, Yellow Oxide

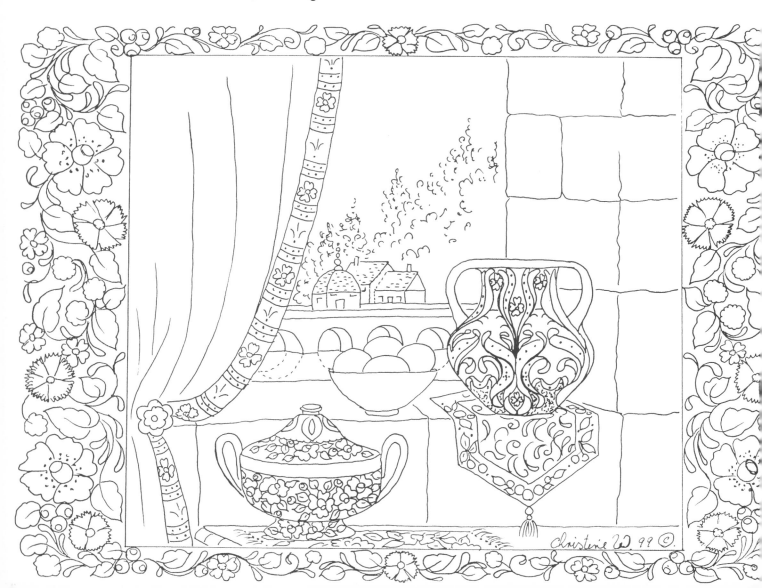

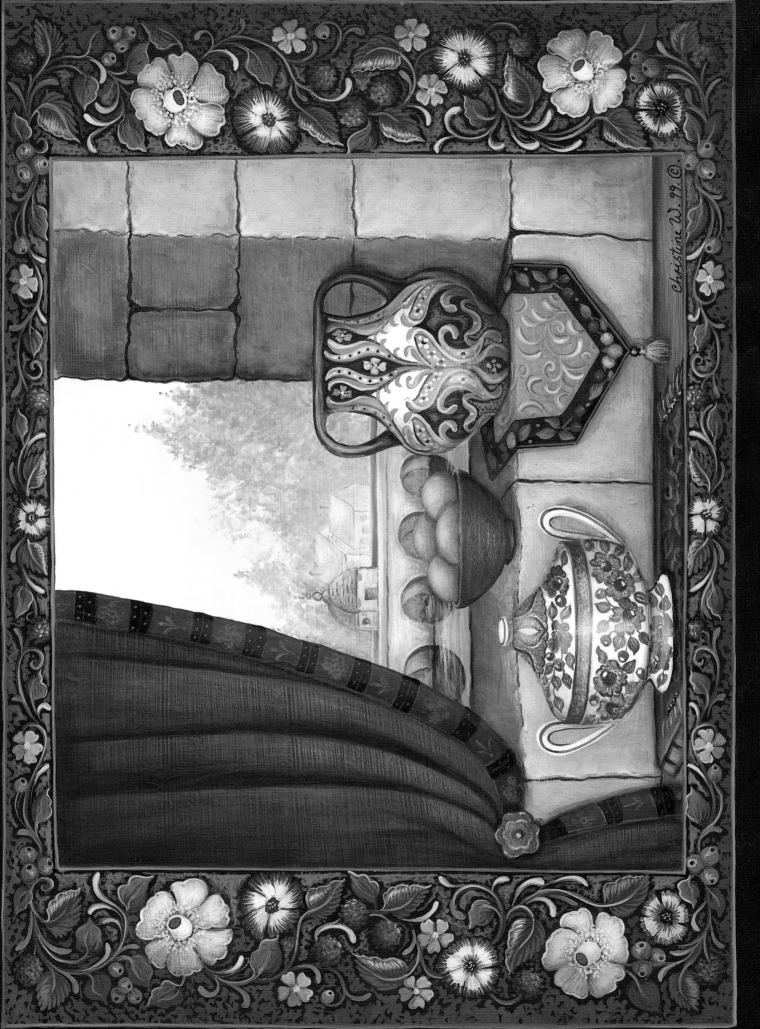

INSTRUCTIONS FOR VIEW OUT THE WINDOW

Trees

Use a No 2 round brush and a watery mix of Pine Green. The more water you use, the paler the colour. Dib-dab the watery mix to form the foliage on the trees. To strengthen the foliage, pick up a little more Pine Green.

Houses, bridge and gaol

Houses: Use the No 2 round brush and Provincial Beige, Warm White and Carbon Black. Mix Provincial Beige and Warm White (2:1) and add a little water. When painting the roof and walls, pull the paint horizontally for the roof and vertically for the walls.

Windows and door: With a dirty brush of the house colour, pick up a small amount of Carbon Black and lightly paint in the windows and door.

Bridge: Pull the paint horizontally when painting the bridge. Give it just one coat. Using a dirty brush, pick up a small amount of Carbon Black and paint the shadows under the arches and under the top edge.

Gaol: Paint the walls. With a dirty brush, pick up Carbon Black and paint the roof, pulling the paint in short strokes. With a dirty brush of the second colour value, pick up Carbon Black and outline here and there and add a few strokes of shadow on the roof. Then paint the windows and door.

River

Use watery Pine Green and paint the river between the arches.

Reflection of bridge: The reflection is painted in the same way and using the same colours as the bridge itself.

Shadow around arch: Pull Carbon Black around the arch and the reflected arch. Paint the tide line on the bridge as well.

Reflected light: Using watery Warm White, lightly streak the paint across the reflection on the water.

Blush: Using a ½ in (12 mm) dagger brush and watery Yellow Light, apply a blush over the trees and very softly up from the trees onto the sky. Blush this colour onto the green water showing under the arches.

Mist over trees and houses

Apply a blush of watery Warm White from the sky down over the trees and the two houses behind the bridge. When dry, repeat the blush.

INSTRUCTIONS FOR INSIDE THE INN

Walls

Use the No 4 filbert brush and the ½ in (12 mm) dagger brush. The colours are Provincial Beige, Smoked Pearl, Warm White, Carbon Black and Yellow Light.

Painting tip: When blocking in the stone blocks, don't apply the paint solidly. Instead, paint the blocks by slip-slapping the paint in all directions, leaving small gaps of the white background colour here and there.

Stone blocks

Mix Provincial Beige and Smoked Pearl (4:1) and use the filbert to slip-slap colour onto the blocks, leaving fine separation lines between the blocks. Paint only one coat.

Black between blocks: With a No 2 round brush, pull creamy Carbon Black between the blocks. Don't paint straight lines—wriggle your brush.

Ghostly highlight: Load your ½ in (12 mm) dagger brush with watery Warm White and wipe both sides of the brush. Blush this onto the front of the stone blocks. Don't paint over the black separations and don't completely cover each block. Paint from the edge of the window onto the wall but don't blush the inside ledge of the window.

Window ledge and wall beside window (shadow side)

With the ½ in (12 mm) dagger brush, blush watery Yellow Light down and across the wall and ledge. It doesn't matter this time if you paint over the black separations. Paint right to the edge of the ghostly highlight.

Shadow on ledge and wall next to window

With the dagger brush, lightly brush watery Carbon Black down the outside edge of the ledge and wall beside the window.

Curtain

For the curtain, use the No 4 filbert brush and the ½ in (12 mm) dagger brush. The colours are Purple Madder, Carbon Black, Rich Gold, Warm White and Cadmium Orange. Block in with two coats of Purple Madder, allowing each to dry. Now retrace the folds and border.

Folds of curtain: Load the No 4 filbert brush with creamy Warm White by wiping the paint onto the brush. Pull your brush back and forward into the paint. Pull the Warm White into the shape of the folds, leaving the Purple Madder showing between the folds. Don't paint the Warm White onto the border.

Wash: With your No 4 filbert brush, paint a thick wash of Purple Madder over the Warm White. When dry, repeat the wash.

Border on curtain

Use the No 1 mini liner brush.

Rose: Paint the outline of the petals and the circle for the centre with one coat of creamy Rich Gold.

Fleurs-de-lis: Paint one coat of Rich Gold.

Black design: Paint the black design in Carbon Black. Let dry. The dots on the black are Rich Gold.

Blush: With the ½ in (12 mm) dagger brush, pull watery Cadmium Orange over the gold and black on the border only.

Gold curtain-holder

Using a No 2 round brush, paint the flower shape with creamy Rich Gold. Using a dirty brush of Rich Gold, pick up a small amount of Warm White and highlight the edges of the petals. Place a shadow around the centre with creamy Carbon Black.

Table

Using the No 4 round brush, block in the table with one coat of Burnt Sienna, pulling the paint horizontally across the table. Using a dirty brush of Burnt Sienna, pick up Warm White, mix the colours together and pull this across the blocked-in colour. Paint Carbon Black shadows for the rope edge and the back of the table.

Green table runner

Using the No 2 round brush, block in the table runner with Teal Green. With a dirty brush of Teal Green, pick up Warm White and paint the floral design with this mix. Now, using a dirty brush of this second colour value, add a few highlights to the floral design.

Fringe: With the No 1 mini liner brush, pull out Rich Gold lines from the edge of the Teal Green runner. Softly paint a Carbon Black shadow between the Rich Gold fringing.

Yellow and black runner

Use the No 2 round brush and Yellow Oxide, Carbon Black, Yellow Light, Pine Green, Permanent Alizarine, Cadmium Orange and Warm White.

Yellow centre: Block-in with Yellow Oxide. Using a dirty brush of Yellow Oxide, pick up Warm White and paint the design with this mix. Use a dirty brush of the second colour value to highlight. Paint a wash of Yellow Light on the front.

Black border: Block in the border with Carbon Black.

Green leaves: Paint the leaves with Pine Green first. Then, with a dirty brush of Pine Green, pick up Warm white and pull the paler green from the tip of the leaf back.

Cherries: Dab Permanent Alizarine neat from the tube to form a circle. The coverage should be solid. Paint a Yellow Oxide circle. Use a dirty brush of Yellow Oxide, pick up Warm White and dib-dab this colour to form a highlight. Then, paint over the Yellow Oxide using watery Cadmium Orange.

Tassel: Using the No 1 mini liner and creamy Carbon Black, paint fine lines coming from the top of the tassel. Using a dirty brush of Carbon Black, pick up a generous amount of Warm White and pull fine lines down over the black.

Blue bowl

With the No 4 round brush, block in the bowl using Ultra Blue Deep. With a dirty brush of Ultra Blue Deep, pick up Warm White and pull across the front. Let dry. Paint a wash of Ultra Blue Deep over the front.

Oranges

For the oranges, use the No 4 filbert brush and Yellow Oxide, Warm White, Cadmium Orange, Yellow Light and Burnt Umber.

Three colour values: Block in with Yellow Oxide. With a dirty brush of Yellow Oxide, pick up Warm White and paint the next two colour values, painting more into the centre of the orange.

First wash: Lightly apply a wash of watery Cadmium Orange onto the centre. Make it stronger on the sides.

Second wash: Apply a wash of watery Yellow Light over the centre of the oranges.

Shadow: Paint a watery Burnt Umber shadow between the oranges to separate them.

Soup tureen

Block-in the tureen with Warm White. Let dry. Trace on the design. With the No 1 mini liner brush and slightly watery Ultra Blue Deep, paint the centre of each rose twice. Then paint the petals once only, pulling your paint towards the centre. Paint the leaves once only. The bands around the top and centre are also painted once only, but this time lightly stipple the colour.

Ghostly highlight: With the dagger brush, paint a blush of watery Warm White down the front of the tureen.

Vase

Use the No 2 round brush for blocking in and the No 1 mini liner for details and linework. The dark blue of the vase is straight Paynes Grey. For the paler blue, use a dirty brush of Paynes Grey and pick up Warm White and paint the design. For the very pale blue edging the design, use a dirty brush of the second colour value and pick up Warm White and outline one side of the motifs.

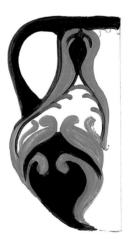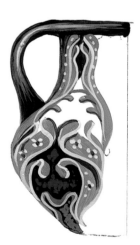

Dark blue: Block in with Paynes Grey.

White area: Block in with Warm White.

Pale blue design: Mix Paynes Grey and Warm White.

Linework: With a dirty brush of the design colour, pick up Warm White and paint the linework.

Small daisies: Paint four Warm White dots to form each daisy. The centre is a dot of Paynes Grey.

Rim and handle: Using a dirty brush of Paynes Grey, pick up Warm White and lightly pull this colour across the top of the rim and halfway down the handles. Keep this colour within the centre of the rim and handles.

Inside the Dark Blue around bottom design: Paint the colour from the rim and handles within the dark blue areas.

Ghostly highlight: With the ½ in (12 mm) dagger brush, very softly blush a ghostly highlight of watery Warm White on the centre of the vase—only once.

INSTRUCTIONS FOR BORDER AROUND SCENE

Background to border

Mix Burnt Umber and Warm White and use a No 2 round brush to dib-dab this colour around the floral design, leaving the black showing around all the design and edges.

Teal Green leaves

With the No 2 round brush paint the stems and leaves in Teal Green. Using a dirty brush of Teal Green, pick up Warm White and pull strokes in from the edge. Paint the vein and stem. With a dirty brush of the second colour value, pick up Warm White and lightly highlight on the inside side of the leaf.

Pine Green leaves

With the No 2 round brush paint the leaves and stems Pine Green. Using a dirty brush of Pine Green, pick up Warm white and pull this colour down from the tip of the leaf. Don't paint the leaves on the shadow side—they are left in the original Pine Green. With a dirty brush of the second colour value, pick up Warm White and lightly outline one edge of each leaf.

Yellow flowers

Paint the petals with creamy Yellow Oxide. Using a dirty brush of Yellow Oxide, pick up Warm White and paint the petals on the inside of the design. With a dirty brush of the second colour value, pick up Warm White and outline one edge of the lighter petals and dib-dab a centre. Apply a wash of watery Yellow Light onto the petals to give them a glow.

Blueberries

Paint each berry with a mix of Ultra Blue Deep and Warm White (2:1). Using a dirty brush of this first colour value, pick up Warm White, paint a circle around the top and softly dab a highlight down the centre.

Raspberries

Dib-dab a cluster of Warm White dots within a circle. Let dry. Paint a thick wash of Purple Madder over the Warm White clusters.

Yellow commas

Paint all the commas with one coat of creamy Yellow Oxide. Using a dirty brush of Yellow Light, pick up Warm White and pull this lighter colour over the commas on the inside of the design. Don't highlight the commas on the shadow side.

Dianthus (pinks)

Use the No 2 round brush. Paint the petals on all the dianthus with creamy Smoked Pearl. When this dries, it will be semi-transparent. Pull creamy Warm White over the petals but leave the petals on the shadow side in Smoked Pearl. Dib-dab a small centre of Carbon Black.

Red and white dianthus: Pull creamy Purple Madder in from the edge of the petals and out from the centre.

Purple and white dianthus: Pull Dioxazine Purple in from the edge of the petals and out from the centre.

Seeds: The seeds are formed with a few dots of Warm White.

Roses

For the roses, use Smoked Pearl, Warm White, Permanent Alizarine and Yellow Light. Firstly, paint all the petals with creamy Smoked Pearl, using the No 2 round brush. Paint only one coat—the colour should be semi-transparent. For the centre bowl, pull the paint around from one side to the other and outline the back edge of the centre circle.

Pull creamy Warm White within the petals, leaving Smoked Pearl on the edge of each petal and at the base and also around the centre front. Outline the edges of the petals with Warm White. Paint the seeds with a circle of Warm White dots. Paint inside the throat with Permanent Alizarine. With the dagger brush lightly paint watery Yellow Light onto the light side of the rose. This is the inside of the design. Paint only once.

Lines around the scene

Paint these lines with a mix of Teal Green and Warm White (2:1).

Country Scene With Roses

From Deborah and Christine:

'We decided it would be fun to paint a project together. Strangely enough, although many embroiderers and weavers collaborate on projects, it seems to be rare among painters. It is a creative experience that we highly recommend.

'The result of our joint efforts is a scene of a romanticised English village with a richly coloured floral border. Though the two styles are very different, the design works as a whole, due to the muted colours in the scene.'

Country scene

Paints

Background colour: Warm White

Decorating colours: Unbleached Titanium, Ultramarine Blue, Olive Green, Moss Green, Brown Earth, Dioxazine Purple, Yellow Deep, Burnt Sienna

INSTRUCTIONS

Preparation

Basecoat the oval of your wood surface with a couple of smooth coats of Warm White, allowing each to dry well.

Transfer the oval pattern using an old sheet of grey transfer paper, very lightly transferring only the minimum of pattern lines—no details. Because this scene involves transparent techniques, dark pattern lines will show through. Try to avoid dirty grey smudges on the white background. Erase any marks with a soft art eraser or a damp cotton bud.

Painting the sky

Remember that the sky is lightest at the horizon. Start at the top with a flat brush and a creamy mix of Unbleached Titanium and Ultramarine Blue to make a light to medium blue. Make long, horizontal strokes across the sky,

mixing in more Unbleached Titanium as you work downwards. At the horizon you can leave some of the white background showing. Leave to dry and repeat if your sky is too streaky. Use a damp cotton bud to clean up the edges and remove the sky colour from the steeple. Paint the clouds with a dirty brush of the sky colour, sideloaded with Unbleached Titanium. Build up the clouds in layers for extra brightness. Add a little Warm White if you like.

Applying the floated washes

Don't overwhelm the scene with colour. Keep as much white space as possible, at least initially. You can always add more at the end. Blot off any excess. Load a ¼ in (6 mm) flat or dagger brush with watery paint, then wipe excess paint from the brush. Test the colour on your palette by making

a stroke and adjust as necessary. Too wet and it will run everywhere. Too dry and the brush will drag. Too much colour and the result will be too harsh.

Establishing the contours

Apply soft floats on the hillsides, at the edges of the stream and under the bridge, using greens mixed from Olive Green and Moss Green. Float soft shadows of Brown Earth on the buildings and bridge and wherever else you feel appropriate.

Painting the stream

Make a medium blue from Unbleached Titanium and Ultramarine Blue and add a little Olive Green to give a medium blue-green. Paint the water with a watery mix of this colour, leaving white areas where the water catches the light. Leave the swan and its reflection unpainted. Deepen the colour at the banks and under the bridge and add touches of other colours from the scene to the water in an impressionistic way.

Painting tip: It's better to start very lightly when applying washes. The colour should be barely there. You can always deepen a wash with a second coat but it's hard to remove a wash that is too heavy.

Stippling the foliage

Make a darkish green using Olive Green and a touch of Ultramarine Blue. Load a stippling brush or an old flat brush, about ¼ in (6 mm) wide, with paint and wipe off excess. Test on your palette before committing to the piece. Stipple the garden area in front of the thatched cottage and the foliage on the trees. You might also wish to lightly stipple areas of the hillside. The stippled garden forms a foundation for the flowers. Allow to dry.

Flower garden

Use a liner brush and paint tiny dot flowers in drifts over the stippled garden area. Use the colours from your palette such as white, yellow and purple.

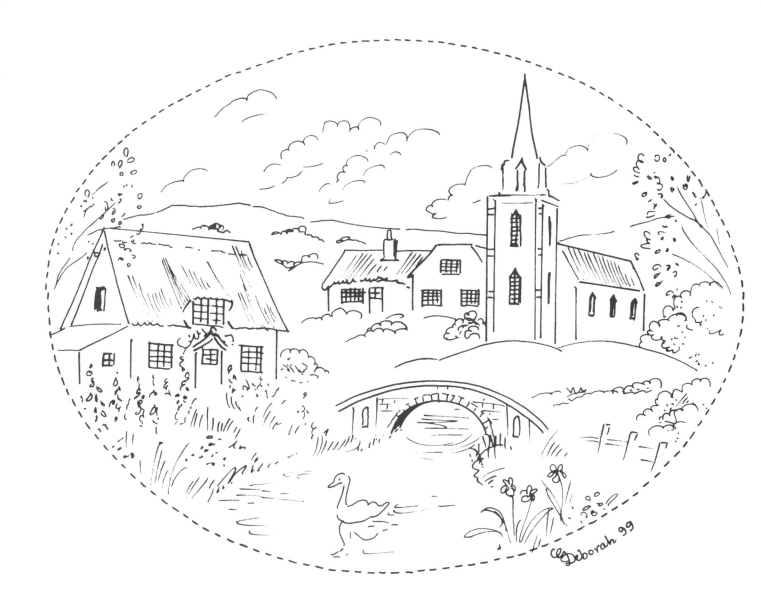

Wash highlights

Christine would call these 'blushes'. Load a dagger brush with watery Yellow Deep and wipe off excess. Paint subtle highlights of this transparent, glowing colour on the buildings and bridge and here and there on the hillsides.

Adding the linework

Flow Medium will help to produce fine linework. Roll your liner or fine-pointed round brush in Flow Medium (and/or water), then fresh paint, and roll off the excess onto a tissue. Now add all the outlines and details, keeping your lines as fine and neat as possible. Use an earth colour for outlining, such as Brown Earth or Burnt Sienna.

Assessing the scene

Decide if the scene needs more contrast and deepen those areas. Add extra details and areas of colour as desired.

Floral and ribbon border

Paints

Background colours: Plum Pink, Warm White

Decorating colours: Burnt Umber, Dioxazine Purple, Napthol Crimson, Napthol Red Light, Pine Green, Plum Pink, Purple Madder, Sap Green, Sapphire Blue, Ultra Blue Deep, Warm White, Yellow Oxide, Yellow Light

INSTRUCTIONS

Background

Paint a mix of Plum Pink and Warm White (2:1) out from the edge of the floral pattern.

Leaves

For the leaves, use your No 2 round brush and Pine Green, Sap Green and Warm White.

First colour value: Block in with Pine Green.

Second colour value: Using a dirty brush containing Pine Green, pick up Warm White, mix the two colours together and paint the veins. Pull the colour between the veins, leaving the blocked-in colour showing each side of the vein.

Third colour value: Using a dirty brush of the second colour value, pick up Warm White, mix the colours together and paint this within the centre of the second colour value and onto the light side of the veins.

Highlight: Highlight the light areas with a touch of Warm White.

Blush: Using your ½ in (12 mm) dagger brush and Sap Green, paint a blush on each leaf—but don't lose the highlight.

Ferns and stems

Paint the ferns and stems as for the leaves.

Red roses

Use the No 4 round brush and Permanent Alizarine, Napthol Crimson and Napthol Red Light.

First colour value: Block in the rose with Permanent Alizarine. Because it is a transparent colour, you may need two coats. Allow each to dry.

Second colour value: Pull Napthol Crimson over each petal, leaving the Permanent Alizarine showing in the shadows.

Third colour value: Lightly pull Napthol Red Light over the two front petals and onto the two folds (also called turnbacks or curled edges).

Seeds: Dot a circle of seeds using Yellow Oxide. Highlight with a few dots of Warm White.

Outlining: Paint watery Warm White on the edge of each fold.

Yellow rose

Use the No 4 round brush and Yellow Oxide, Warm White and Yellow Light.

First colour value: Block in the petals with two coats of the following mix: Yellow Oxide, Warm White and Yellow Light (2:1:1).

Second colour value: Pull Warm White down from the edge of each petal, towards the centre and onto the folds.

Third colour value: Pull creamy Yellow Light from the centre, feathering off your strokes halfway up the petals.

Seeds and centre: Paint with Burnt Umber. Highlight the centre, but not the seeds, with Warm White.

Red and yellow rose buds
Paint the buds in the same colours as the roses.

Purple rose
Use Dioxazine Purple, Warm White, Yellow Light and Yellow Oxide.

First colour value: Block in with Dioxazine Purple.

Second and third colour values: Using a dirty brush of Dioxazine Purple, pick up Warm White and progressively paint the next two colour values.

Highlight: Paint Warm White across the centre of the front petal and the edge of the fold.

Yellow centre glow: Pull Warm White out from the centre, feathering off your strokes.

Blush: Using your dagger brush, apply a blush of watery Yellow Light over the Warm White centre.

Seeds: Paint the seeds with Yellow Oxide. Then, using a dirty brush of Yellow Oxide, pick up Warm White and highlight a few seeds.

Purple lilac
First colour value: Block in all the petals with Dioxazine Purple and the No 2 round brush.

Second colour value: With a dirty brush of Dioxazine Purple, pick up Warm White, mix the colours together and paint this second value onto a lesser area of each petal.

Third colour value: Make the third colour value and paint an even smaller area within the second colour value.

Highlight: Dib-dab Warm White onto some of the petals in the light.

Blush: Apply a blush at the base of the lilac with watery Dioxazine Purple and the dagger brush.

Blue lilac

First colour value: Block in all the petals with the No 2 round brush and Ultra Blue Deep.

Second colour value: Using a dirty brush of Ultra Blue Deep, pick up Warm White, mix the colours together and paint the petals, leaving some petals on the outside of the flower in the first colour value.

Third colour value: Using a dirty brush of the second colour value, pick up Warm White and paint fewer petals than you did with the previous mix.

Highlight: Paint Warm White onto the petals around the top area of the flowers.

Blush: Using watery Ultra Blue Deep and your dagger brush, blush a blue shadow at the base of the flower.

Centres: Paint the dot at the centre with a No 1 mini liner brush and Warm White.

Heartsease

Use a No 2 round brush and Dioxazine Purple and Warm White. The two top petals are Dioxazine Purple, the two side petals are Warm White. The bottom petal is Yellow Oxide.

Bow and ribbon

Use Sapphire Blue, Warm White and Ultra Blue Deep.

First colour value: Block in with a mix of equal parts of Sapphire Blue and Warm White.

Second and third colour values: Using a dirty brush of the first mix, pick up Warm White and progressively paint the second and third colour values. Leave the first colour value inside the loops of the bow and behind the folds in the ribbon.

Highlight: Paint Warm White within the centre of the bow, from the top edge down through the centre and on the front loops of the ribbons.

Outlining behind the loops: Paint a fine line of creamy Ultra Blue Deep to separate the front from the back.

Floral Illumination

From Christine:

'To paint is to describe your imagination in colour. I do hope you enjoy the merging of two painters' imaginations!'

From Deborah:

'Another creative collaboration, this time to capture autumn flowers. Chris has painted roses, violets and cyclamen in a pretty bouquet while I have framed the flowers with a trellis, inspired by a border device popular in late mediaeval manuscripts. In the early fifteenth century illuminators sometimes used diagonal open latticework, enclosing a flowerhead or strawberry within each diamond. A bumble bee motif ties everything together.'

The floral bouquet (Christine)

Paints

Background colour: Yellow Oxide

Decorating colours: Burnt Sienna, Burnt Umber, Cadmium Orange, Carbon Black, Dioxazine Purple, Indian Yellow, Napthol Red Light, Permanent Alizarine, Pine Green, Sap Green, Smoked Pearl, Ultramarine, Warm White, Yellow Oxide

INSTRUCTIONS

Leaves

Use Pine Green, Warm White, Sap Green and Burnt Sienna and your No 4 round brush.

First colour value: Paint all the leaves with two coats of creamy Pine Green, allowing each to dry.

Second colour value: Using a dirty brush of Pine Green, pick up Warm White and mix the colours. Pull in from the edge of the petals and down towards the base of the leaves, leaving the first colour value showing between the leaves and at the base.

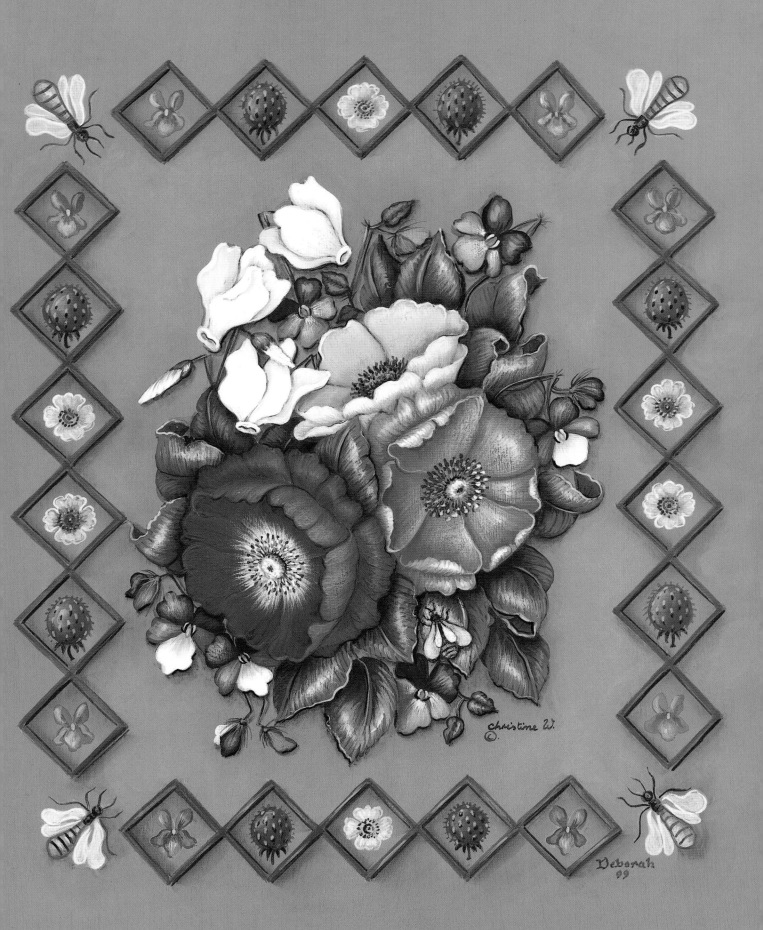

Christine W.
©.

Deborah
99

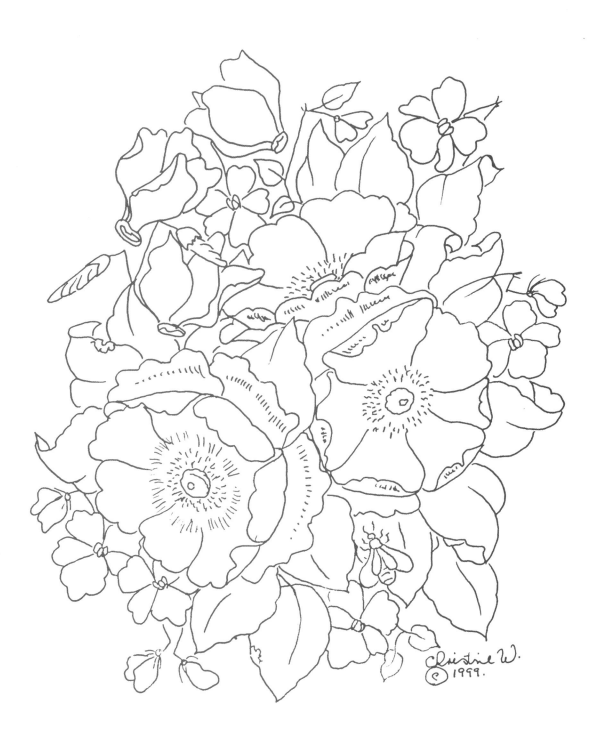

Third colour value: Using a dirty brush of the second colour value, pick up Warm White and mix the colours together. Paint the veins first, then pull in from the edge of the leaf towards the veins. Don't paint up to the veins—leave your second colour value showing on either side of the vein. This third colour value produces a mottled effect so don't overwork this coat.

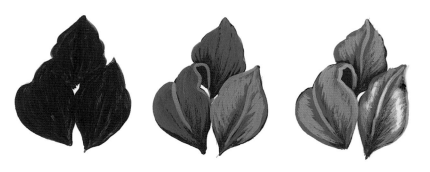

Highlight: Paint a creamy Warm White highlight within the centre half of the leaves.

Blush: Using watery Sap Green and your ½ in (12 mm) dagger brush, apply a blush out from the shadows of the leaves. Don't cover all your highlights.

Outlining: Outline one edge of each leaf with a pale green (Warm White and a touch of Pine Green) and a No 1 mini liner brush.

Rust: Use your No 4 round brush and a slightly watery Burnt Sienna and smudge this colour here and there on the edges of the petals. Dib-dab a Carbon Black spot onto the edge of the Burnt Sienna smudge.

Cyclamen

First colour value: Pull Smoked Pearl down from the edge of the petals. Use the Smoked Pearl straight out of the tube—don't add water.

Second colour value: Pull down creamy Warm White over the Smoked Pearl, leaving the Smoked Pearl in the shadows and in between the petals as separations.

Outlining: Using Warm White neat from the tube, paint the folds or 'turnbacks' on the petals.

Violets

There are two different types of violets in the bouquet but they are painted with the same colours.

Upper petals: Block in the upper petals with Dioxazine Purple. Then, using a dirty brush of Dioxazine Purple, pick up a small amount of Warm White and mix to form the second colour value. Paint this within the petals, covering about a third of the area. Use a dirty brush of the second colour value and pick up Warm White to create the third colour value. Paint this within the second colour value. These three colour values are on all the violets.

Blue petals on all the violets: Mix Ultramarine and Dioxazine Purple (2:1) plus a small touch of Warm White. Block in all the blue petals on both types of violet, then use the dirty brush method to create second and third colour values.

White bottom petals: For the white bottom petals, use creamy Warm White and paint two coats, allowing each to dry.

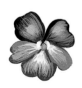

Centres: The seeds are Yellow Oxide. Paint Warm White each side of the yellow seed.

Orange on white petals: Load your brush with slightly watery Cadmium Orange, wipe the brush and then lightly pull down on the white petals.

White on blue petals: Pull Warm White down and out onto the blue petals.

Yellow rose

Use Warm White, Yellow Oxide, Indian Yellow and your No 4 round brush.

First colour value: Mix Warm White and Yellow Oxide (4:1) and pull this colour down from the edge of the petals into the centre.

Second colour value: Using a dirty brush of the first mix, pick up Warm White, mix the colours together and pull down over the first colour value. Remember to leave that first colour value showing for the separation between petals.

Third colour value: Using a dirty brush of the second colour value, pick up Warm White and pill this down to cover about a third of each petal.

Highlight: Paint Warm White on the front petals. Outline the top edges of the back petals.

Blush: Using watery Indian Yellow and your dagger brush, apply a blush inside the throat of the rose and on the front petals as a shadow.

Seeds: The seeds are Burnt Umber.

Red rose

Use Permanent Alizarine, Warm White, Napthol Red Light, Yellow Oxide and your No 4 round brush. Block in the rose with two coats of Permanent Alizarine, allowing each to dry. Paint the front petals only with creamy Warm White. Apply a thick wash of Permanent Alizarine over the Warm White.

Highlight: Pull a highlight of creamy Napthol Red Light halfway down the front petals.

Centre: For the white centre, pull creamy Warm White out from the centre onto the Permanent Alizarine, feathering off at the end of your strokes. Paint the yellow centre by pouncing Yellow Oxide. Tip into Warm White and highlight. Shadow under the yellow centre with a 'dib-dab' line of Burnt Umber. Dab a dot in the centre.

Seeds: Dot Yellow Oxide seeds around the centre. Add a few dark seeds with dots of Burnt Umber over the yellow.

Pink rose

Use Warm White, Permanent Alizarine, Indian Yellow, Yellow Oxide, Burnt Umber and your No 4 round brush.

First colour value: Mix Warm White and Permanent Alizarine (2:1) and pull down from the edge of each petal into the centre. Don't forget the folds.

Second colour value: Using a dirty brush of the first colour value, pick up Warm White, mix the colours together and pull this mix over the first colour value. Leave the first colour value showing between the petals and under the folds.

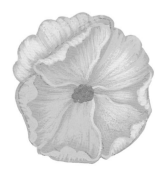
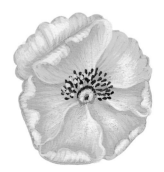

Third colour value: Using a dirty brush of the second colour value, pick up Warm White, mix and highlight the folds and within the petals.

Highlight: Paint creamy Warm White within the third colour value.

First blush: The first blush is watery Permanent Alizarine. Use your dagger brush and apply the blush under the folds to strengthen the shadows.

Second blush: A second blush of watery Indian Yellow is applied softly onto the area left of the centre.

Centre and seeds: Paint the centre and seeds as for the red rose.

Shadow blush: Using watery Burnt Umber and your dagger brush, shade all around the leaves and violets.

Black shadow: Paint a black shadow line here and there next to the leaves.

Bumble bee
Refer to Deborah's instructions on page 128.

The trellis border (Deborah)

Paints
Decorating colours: Brown Earth, Brown Madder, Burnt Sienna, Carbon Black, Dioxazine Purple, Naples Yellow Hue, Permanent Alizarine, Pine Green, Raw Sienna, Titanium White, Turners Yellow, Ultramarine, Unbleached Titanium

INSTRUCTIONS

Preparation
Transfer the border design with white transfer paper.

Trellis

Paint the lattice with a fine round brush and Burnt Sienna. Try to paint the lines an even thickness but don't worry if there is a little variation.

Floated shadows: When the lines are dry, lightly pre-wet the area to be shaded. Sideload a flat brush with Raw Sienna and perhaps a touch of Brown Earth and float shadows as shown in the step-by-step painting. Do only one edge of each diamond at a time and allow to dry, otherwise you will lift the float that you have already done. Let dry.

Optional: Use a liner brush to paint a drop-shadow line of Brown Earth plus Carbon Black on the inside left of each diamond and on the outside bottom right. Highlight some of the lengths of lattice with a touch of Raw Sienna plus a little Naples Yellow Hue.

Violets

Using a small round brush, basecoat each violet with a mix of Dioxazine Purple, Ultramarine and Unbleached Titanium to make a medium blue-purple. Brush-mixing these colours adds variety. Deepen the area at the centre of each violet with a darker version of the mix (less Unbleached Titanium). Highlight the petals by layering progressively lighter versions of the medium blue-purple mix (extra Unbleached Titanium). Paint a Turners Yellow elongated dot at the centre.

Wild strawberries

Base with a brush-mix of Brown Madder and Permanent Alizarine. You will need two coats. Highlight by loading a small flat brush with the base mix, then sideloading Turners Yellow. Float this on one side of each strawberry. Build up the highlight by floating a little Naples Yellow Hue. When dry, paint tiny Turners Yellow teardrop strokes on the strawberry as shown on the pattern. For the yellow teardrops on the highlight side, mix in Naples Yellow Hue or even Unbleached Titanium to make them visible. Place a very tiny dot of Brown Earth or Carbon Black at the bottom of each teardrop. Allow to dry. You may wish to sideload the small flat brush with Brown Madder plus a touch of Brown Earth and float this on the shadow side of each strawberry.

Strawberry sepals and stem: Add fine Pine Green sepals and stems.

Yellow blossom

Base each petal with Raw Sienna plus a touch of Brown Earth—leave the centre unpainted. Let dry. Build up highlights by overstroking with Turners Yellow, then add Unbleached Titanium to the mix. The dot at the centre and the seeds are Pine Green. Outline the frilly edges of the petals with a liner brush and Titanium White. (Warm White is an option but won't show up quite as well.)

Pink blossom

Paint in the same manner as the yellow blossom, but base the flower with a mix of Permanent Alizarine and Naples Yellow Hue. If the resulting hue is too lolly pink for your taste, add a little Brown Earth to 'dirty' the colour. Build up highlights with Permanent Alizarine plus Naples Yellow Hue. Add some Unbleached Titanium for the final highlights. Outline the frilly edges with Warm White.

Bumble bees

Before you start painting the bees, use a sideloaded flat brush to float a soft shadow of Raw Sienna and a touch of Brown Earth beside and under each bee. Paint the wings with watery Unbleached Titanium. Let dry. Repeat. Outline each wing with a liner brush and Titanium White. Paint the body with Raw Sienna plus a little Brown Earth. When dry, highlight one side with Turners Yellow. Highlight again, this time with Naples Yellow Hue. Allow to dry. Add the Carbon Black stripes. Let dry. With a small flat brush, float a mix of Raw Sienna and a little Brown Earth down the shadow side of the body. Paint the head, legs and feelers with Carbon Black plus a tiny touch of Brown Earth. Keep the lines very fine.